EDINBURGH'S FESTIVAL AND KING'S THEATRES

THROUGH TIME

EDINBURGH'S FESTIVAL AND KING'S THEATRES

THROUGH TIME

Jack Gillon

AMBERLEY

First published 2016

Amberley Publishing
The Hill, Stroud, Gloucestershire, GL5 4EP
www.amberley-books.com

Copyright © Jack Gillon, 2016

The right of Jack Gillon to be identified as the Author
of this work has been asserted in accordance with the
Copyrights, Designs and Patents Act 1988.

ISBN 978 1 4456 5460 7 (print)
ISBN 978 1 4456 5461 4 (ebook)

British Library Cataloguing in Publication Data.
A catalogue record for this book is available from the
British Library.

Typesetting by Amberley Publishing.
Printed in Great Britain.

Foreword

The Festival City Theatres Trust is the custodian of the King's and Festival Theatres – two very special historic buildings – and the Trust presents the best possible local, national and international productions in these distinctive and extraordinary theatres.

The buildings, still owned by the council but operated and managed by the Trust, contain far too many stories for any one book to hold. What Jack Gillon has been able to do in this volume is to place the Festival and King's Theatres within the wider history of popular entertainment in Edinburgh. With great skill, he has highlighted the landmark moments of Edinburgh's illustrious theatre history and remembered the great men and women who created the legacies of the Festival and King's Theatres. There are some fascinating stories here, some well known and others less so, and I'm sure for many this book will prove to be a starting point for exploring these remarkable theatres.

Duncan Hendry
Chief Executive, Festival City Theatres Trust

Acknowledgements

I have enjoyed many entertaining visits to the Festival and King's Theatres over the years and it has been a pleasure to delve deeper into the history of these two outstanding theatre venues.

I would like to thank Duncan Hendry, Chief Executive of the Festival City Theatres Trust, and all the staff at the Festival and King's Theatres for assistance with the book. Special thanks to Fiona Syme, Catherine Bromley and Megan McCutcheon for all their help.

As ever, a big thank you to Emma Jane for her patience and support.

Archive images are courtesy of the Festival City Theatres Trust.

Introduction

The Festival and King's Theatres are two of Scotland's most historic theatrical venues and both have their own engrossing stories to tell.

The stunningly preserved King's Theatre, the Grand Old Lady of Leven Street, first opened 8 December 1906 and is rich in theatrical tradition. It is a premier venue for the best in theatre and plays host to Edinburgh's annual Christmas pantomime.

The glass frontage of the Festival Theatre forms a glowing night-time landmark on Nicolson Street and encloses a magnificent auditorium that dates back to 1928. It is Edinburgh's leading theatre for world-class opera, dance and large-scale musicals.

The Festival and King's Theatres were merged in 1997 under the management of the Festival City Theatres Trust.

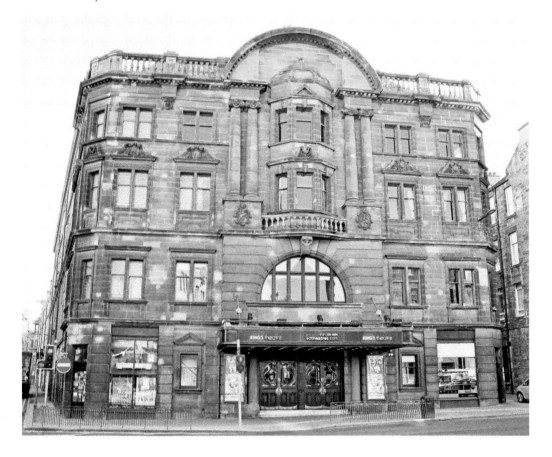

The King's Theatre.

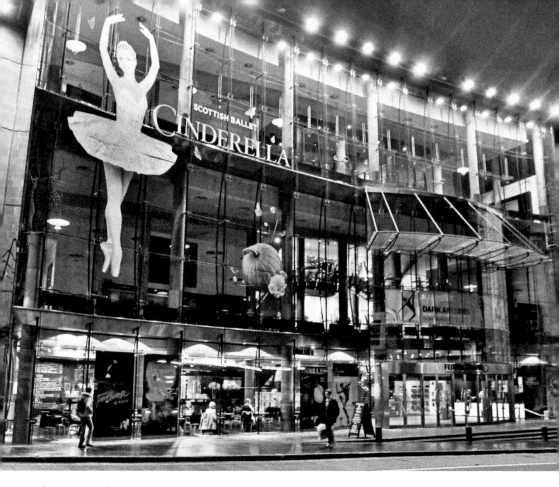

The Festival Theatre.

Early Theatre in Edinburgh

Theatre in Edinburgh has a long history. Theatrical activity was originally centred on the Palace of Holyroodhouse with performances in the Royal Tennis Court, a covered building just outside the gates of the palace. In 1601, an English company of actors, headed by a Laurence Fletcher, 'comedian to his Majestie', appeared at the Tennis Court. It is reputed that William Shakespeare was among Fletcher's company and that he sketched out a plan for *Macbeth* at the time. The last recorded theatrical presentation at the Tennis Court was in 1714, when *Macbeth* was performed 'in the presence of a brilliant array of Scottish Nobles after an archery competition'.

The use of the Tennis Court as a theatre was often in defiance of the city churchmen. In 1599, the clergy took out an interdict against a company of English comedians, and in 1710 the theatre was denounced as a 'hotbed of vice and profanity'. The Royal Tennis Court was eventually turned into a weaver's workshop and was finally burned down in 1771.

In 1736, Allan Ramsay converted a building in Carrubber's Close for use as a theatre – it was soon closed due to the hostility of the kirk to theatrical performances. A pamphlet of the period described actors as, 'the most profligate wretches and vilest vermin that Hell ever vomited out'.

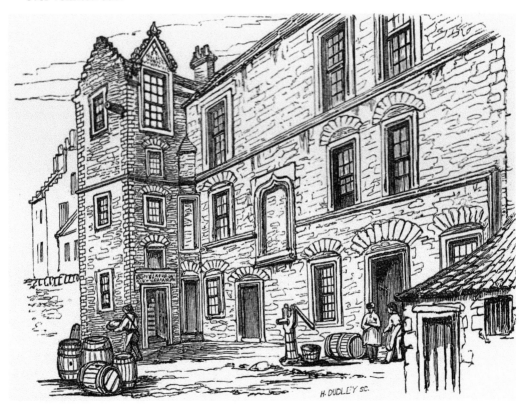

The Tailors' Hall.

The Tailors' Hall in the Cowgate dates from 1621. Now the Three Sisters pub, the Incorporation of Tailors built it as a corporation hall. The building was used as a theatre by itinerant players from 1727 to 1753. Legend has it that in 1741 three beautiful sisters, Cath, Kitty and Maggie Mackinnon, drew exuberant crowds to the theatre to witness performances of their accomplished singing and dancing. The incessant hostility of the clergy to the shows resulted in the theatre's licence being withdrawn by the town council. However, the sisters were eventually caught giving clandestine performances and were sentenced to death by being sealed into a room in the theatre.

The Canongate Playhouse in Playhouse Close was Scotland's first custom-built theatre. It opened in November 1747 with a concert followed by a performance of *Hamlet*. In 1756, the theatre was the venue for the first ever performance of the Revd John Home's play, *Douglas*. The play was met with such intense fervour that a member of the audience is reputed to have called out, 'Whaur's yer Wullie Shakespeare noo.' In 1767, much of the auditorium and stage were destroyed by rioters protesting against the removal of one of their favourite actors from the company.

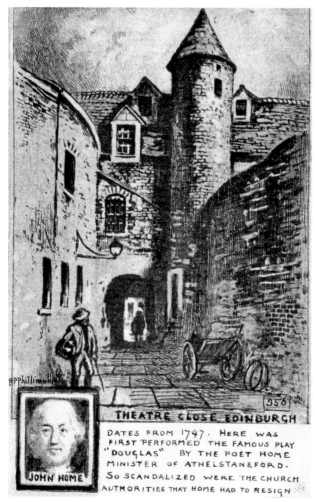

The Canongate Playhouse.

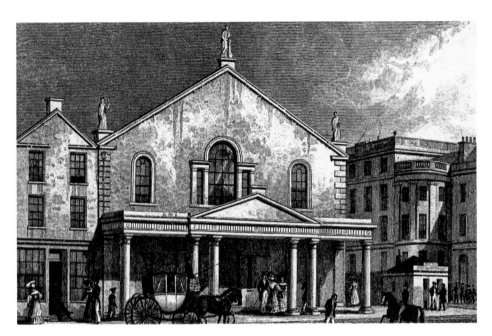

The Theatre Royal, Shakespeare Square.

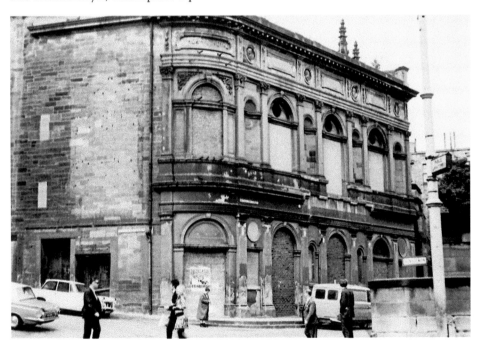

The Theatre Royal, Broughton Street, prior to its demolition in the late 1950s. A second theatre with the name the Theatre Royal was built on Broughton Street. This was damaged by fires on a number of occasions. After the final fire in 1946, the building stood as an empty shell for a number of years, until finally being demolished.

The medallions depicting Molière, Shakespeare, Sir Walter Scott and Dante at the upper level of the building were salvaged and are now on display at the top level of the stairway at the Festival Theatre along with playbills from the Theatre Royal.

In December 1769, the Theatre Royal in Shakespeare Square at the north end of North Bridge opened to the public for the first time. The Theatre Royal's rather plain exterior, which was simply ornamented by a pediment with a central statue of Shakespeare and the Tragic and Comic muses at the sides, contrasted with the elegance of the interior. Robert Henry Wyndham (1814–94), an actor-manager who ran a number of theatres in Edinburgh, including the Queen's on the site of the Festival Theatre, took over the lease of the Theatre Royal in 1853 when Henry Irving was a juvenile lead. In 1859, the site was sold for the construction of the new post office.

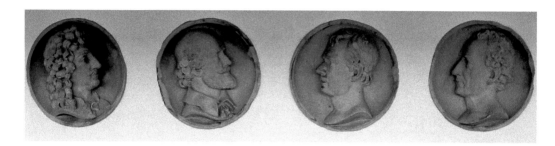

The medallions on display at the Festival Theatre.

The Edinburgh Festival Theatre

The Site

The site of the Festival Theatre has been occupied by a bewildering succession of circuses and performance halls since 1830 and is the longest serving theatre venue in Edinburgh.

Ducrow's Circus was the first venue to be erected on the site, in around 1820 – it was later renamed the Royal Amphitheatre. In 1846, this became James Thorpe Cooke's Circus and in quick succession had the following names: Pablo Fanque's Amphitheatre (1853), the Dunedin Hall (1854), Cooke's Royal Circus (1858), Sanger's Circus and Hippodrome (1859). These venues were used for various types of entertainment – waxwork and diorama exhibitions, clowns, equestrian circuses, theatrical performances and musical concerts. In

This theatre was purchased for the people of Edinburgh by The City of Edinburgh District Council in April 1991.

It is the longest continuous theatre site in Edinburgh, occupied since 1830 by the Queen's Hall, Dunedin Hall, Royal Amphitheatre, Newsome's Circus, Empire Palace Theatre, Empire Theatre, and now the Edinburgh Festival Theatre.

Above: Inscribed stone at the entrance to the Festival Theatre which commemorates the historic venues on the site.

Right: Playbill for Newsome's Circus.

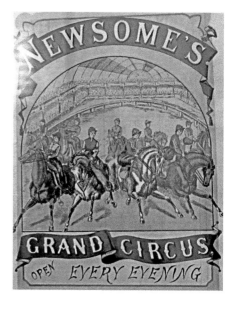

NEWSOME'S

GRAND CIRCUS

OPEN EVERY EVENING

1861, the site was occupied by the short-lived Alhambra Music Hall, which closed in 1862. A more substantial building named the Southminster Theatre was opened on the site in March 1863. It was gutted by a fire on Sunday 14 March 1875 and was replaced rapidly by the Queen's Theatre, which opened on 13 December 1875. This in turn was destroyed by a fire on 4 April 1877 and within seven months was replaced by the 3,000-seater Weldon's Circus. Weldon's became Newsome's Circus in 1879, but the change of name did not stop it being burned to the ground in a fire on 13 September 1887. The combination of timber construction and candle or gas lighting made theatres particularly vulnerable to fires at this time.

Howard Edward Moss of the Theatre of Varieties on Chambers Street had rented the circus from the proprietor and had almost completed negotiations for a three-year lease at the time of the fire. Newsome's reopened on 31 December 1888. However, by May 1890 Moss had acquired the site with the intention of developing a new theatre.

For the Benefit of Mr Kite

In 1853, the site of the Festival Theatre was occupied by Pablo Fanque's Amphitheatre. Pablo Fanque (1796–1871) was the stage name of William Darby, a skilled equestrian showman and circus owner. His touring circus was one of the most popular in Victorian Britain for many years.

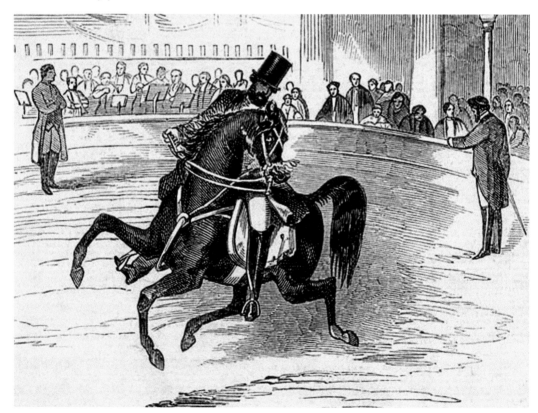

Pablo Fanque displays his equestrian skills.

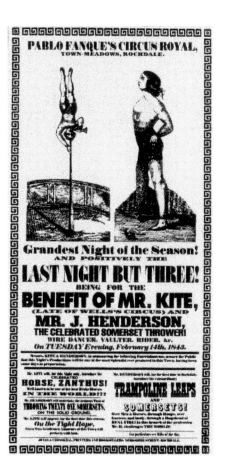

The poster for Pablo Fanque's Circus Royal, which inspired John Lennon.

Pablo Fanque achieved fame again in June 1967 when he was name checked in the Beatle's song 'Being for the Benefit of Mr Kite' on the *Sergeant Pepper's Lonely Hearts Club Band* album. It seems that John Lennon's lyrics were inspired by the contents of an 1843 playbill for Pablo Fanque's Circus Royal, which he had bought in an antique shop. The title of the song and most of the lyrics are taken directly from the poster. William Kite worked in Fanque's circus from 1843 to 1845 and the poster shows him balancing on his head on top of a pole while playing a trumpet.

Two of Fanque's children who died in infanthood are interred at Edinburgh's Warriston Cemetery.

Sir Howard Edward Moss and Frank Matcham

The creation of what was to be a magnificent new theatre on the site was a partnership between two of the great men associated with the theatre at the time.

Sir Howard Edward Moss's (1852–1912) father was an entertainer who toured with a diorama show as the 'fiddling comedian'. Moss senior took over the Lorne Music Hall in Greenock in the 1870s, which Edward started to manage in 1872. Edward opened the first Empire Theatre on the Nicolson Street site in 1892, and by 1899 had incorporated a number of theatres across the country into the Moss Empire chain – the biggest assemblage of variety theatres in Britain with over fifty venues at its peak. Moss was also

Sir Howard Edward Moss.

Frank Matcham.

a major figure of the transformation of the old music hall tradition into modern variety. He was knighted in 1905 for services to theatre and for his charity work.

The new theatre was designed by the celebrated theatre architect Frank Matcham (1854–1920) – 'Matchless Matcham'. He completed his first theatre design in 1879 and went on to create hundreds of unique venues throughout the country. Matcham never formally qualified as an architect, learning his profession by apprenticeship and experience. His theatres are notable for their stylish and subtly luxurious interiors and eclectic mix of architectural styles. He also established new innovative principles in providing clear sight lines and improved safety standards.

The partnership of Moss and Matcham was to continue for the next twenty years, during which time they created numerous splendid theatres considered prime venues both for patrons and for the acts that performed in them.

The Empire Palace

Nothing is harder to design than a good theatre. It conforms to no ordinary conditions; even its shape, as a rule, is unknown to geometrical terminology. It must house a thousand people who are not only to hear and see, but also to think and feel, as one. It is a place of illusion – at once a grandstand for a spectacle and a family circle in which a story may be told. It is everything from a temple to a peep-show.

Foreword by W. Bridges-Adams in G. A. Jellicoe's,
The Shakespeare Memorial Theatre, 1933

Building work on the new theatre started in February 1892. The existing building was completely demolished and a number of neighbouring properties purchased and removed to make way for the new building.

At the Edinburgh Empire Palace, Moss and Matcham created an immensely impressive venue to host the very best in show business of the time. The main auditorium was setback from the Nicolson Street frontage, allowing revenue generating commercial premises to flank the narrow but ostentatious entrance – an Oriental-style tower with a gilded onion dome topped by a life-sized statue of a female figure. It was a long-standing Edinburgh joke that there was a romantic relationship between the statues of the woman on the Empire's dome and the Golden Boy on the University's Old College.

The lavish interior was decorated with a grandiose array of Eastern-inspired plasterwork, red plush seats, marble staircases, huge chandeliers, mosaic floors and waterfalls, all of which were illuminated by electric lighting. The opulent interior was designed to give patrons a sense of luxury and the chance to experience another more sumptuous world during their visit. The auditorium featured a novel sliding roof for ventilation (a much-needed convenience due to the abundant smoking in the auditorium) and seated 3,000 people on four levels. The orchestra pit and stage could be adapted as a circus ring and a menagerie of animals could be accommodated on site. It was described as 'an edifice of magnificent proportions ... a temple of amusement of a character hitherto unknown in Scotland... in point of beauty, luxury, and commodiousness not to

be surpassed by any other edifice of the kind in the country.' Moss was convinced that his new 'dream palace' would be the premier variety house in Scotland.

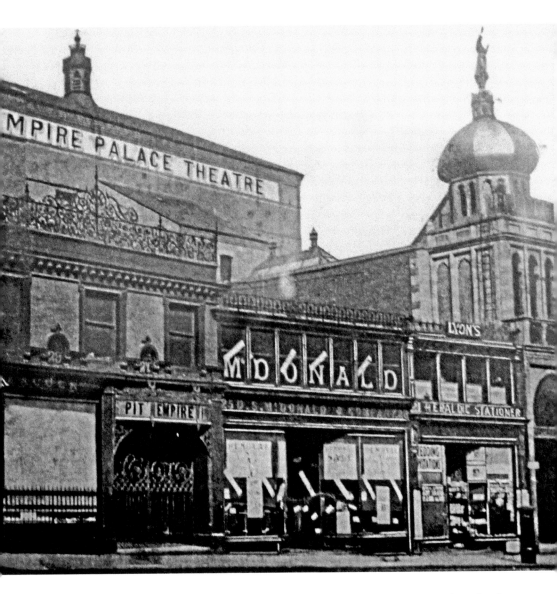

The Empire Palace. Note the separate entrance to the Pits – there was a class divide at most theatres at the time with separate entrances to the different parts of the theatre. Ladies' and gentlemens' retiring rooms were provided for the more affluent customers.

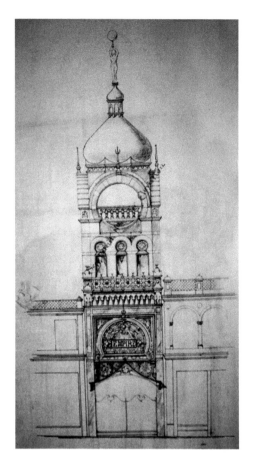

The main entrance and tower at the Empire
Palace.

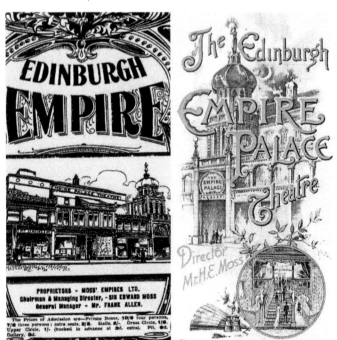

Flyers for the Empire Palace.

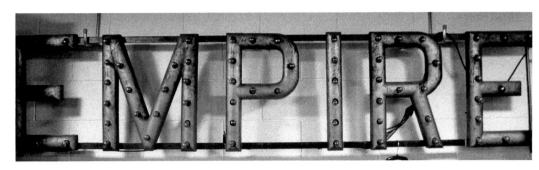

An original old, wooden illuminated sign from the Empire Palace, now on display in the Green Room of the Festival Theatre.

The salvaged sign can be seen in this early view of the Empire Palace.

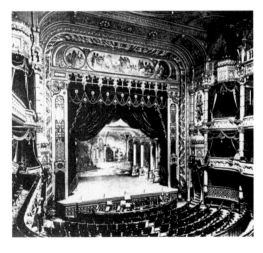

The interior of the Empire Palace Theatre.

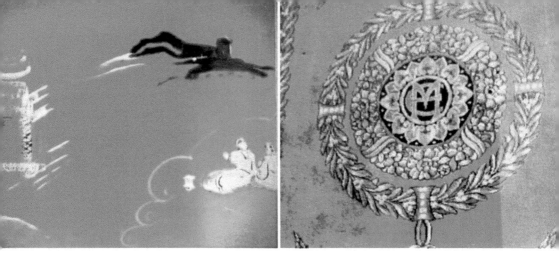

Sections of original wallpaper and carpet from the Empire Palace. The carpet has an 'M' motif for Moss Empires.

The Opening Night of the Empire Palace

The new Empire Palace opened on 7 November 1892, and the first-night audience was awed when the house lights were turned up to allow a full appreciation of the sumptuous setting. The show included a number of firm favourites with the Edinburgh audience: singers; comedians; performing cockatoos; Professor Marvelle and his canine wonders; acrobats and Evans & Luxmore, who were billed as Musical Eccentrics. The theatre was filled to capacity and thousands more stood outside to admire the illuminated entrance and dome after the House Full notice boards went up.

Moss had given Edinburgh the most lavish theatre they had ever seen and the Empire Palace proved to be extremely popular. In 1893, the theatre was described as 'the most favourite evening resort in the city'.

It soon began to attract a wide selection of the very best-known performers and variety shows of the time. Moss Empires, with their national circuit of theatres, the 'Moss Route', were also able to attract the biggest stars of the day. A contract from Moss Empires assured acts regular work as they moved around the company's many theatre venues – thirty-eight in 1932.

From its opening, the theatre featured a diverse blend of performances – variety, musicals, operas, big bands, popular singers and even ice shows.

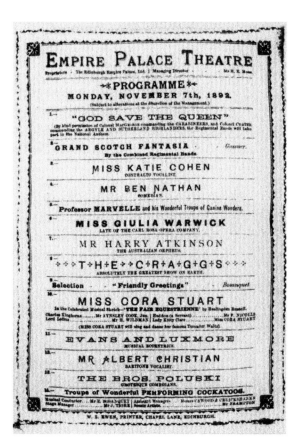

EMPIRE PALACE THEATRE

Proprietors · The Edinburgh Empire Palace, Ltd. | Managing Director · Mr H. E. Moss

✦ PROGRAMME ✦

MONDAY, NOVEMBER 7th, 1892.

(Subject to alterations at the discretion of the Management.)

1.— **"GOD SAVE THE QUEEN"**

(By kind permission of Colonel MacGregor commanding the CARABINEERS, and Colonel Chates commanding the ARGYLE AND SUTHERLAND HIGHLANDERS, the Regimental Bands will take part in the National Anthem.

2.— **GRAND SCOTCH FANTASIA** · · · *Gonnery.*
By the Combined Regimental Bands

3.— **MISS KATIE COHEN**
CONTRALTO VOCALIST.

4.— **MR BEN NATHAN**
COMEDIAN.

5.— Professor **MARVELLE** and his Wonderful Troupe of Canine Wonders.

6.— **MISS GIULIA WARWICK**
LATE OF THE CARL ROSA OPERA COMPANY.

7.— **MR HARRY ATKINSON**
THE AUSTRALIAN ORPHEUS.

✧ ✧ T ✦ H ✦ E ✦ ✦ C ✦ R ✦ A ✦ G ✦ G ✦ S ✧ ✧
ABSOLUTELY THE GREATEST SHOW ON EARTH.

8.— **Selection** · · · "Friendly Greetings" · · · *Bosanquet.*

9.— **MISS CORA STUART**
In the Celebrated Musical Sketch "THE FAIR EQUESTRIENNE" by Bastingden Russell.

Charles Kinghorne Mr AYNSLEY COOK, Jun. | Huddon (a Servant) Mr F. NICOLLS
Lord Loftus Mr H. WILDMAN | Lady Kitty Clare Miss CORA STUART

(MISS CORA STUART will sing and dance her famous Toreador Waltz.)

10.— **EVANS AND LUXMORE**
MUSICAL ECCENTRICS.

11.— **MR ALBERT CHRISTIAN**
BARITONE VOCALIST.

12.— **THE BROS. POLUSKI**
GROTESQUE COMEDIANS.

13.— Troupe of Wonderful PERFORMING COCKATOOS.

Musical Conductor · Mr E. BONANQUET | Assistant Managers · · Messrs CAWOOD & CRUICKSHANKS
Stage Manager · · Mr J. TIGHE | Scenic Artists · · · Mr FRAMPTON

W. S. EWEN, PRINTER, CHAPEL LANE, EDINBURGH.

Left: Playbill for the opening night of the Empire Palace.

Below: A playbill from the Empire Palace in 1900 which illustrates the diversity of acts that appeared at the theatre – singers, dancers, trapeze acts.

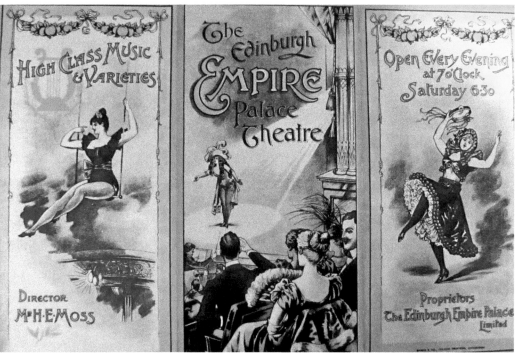

Vesta Tilley

In October 1893, Vesta Tilley, one of the biggest music hall acts of the age, 'whose voice, gesture and acting were in perfect accord', appeared at the Empire Palace. Vesta Tilley (1864–1952) was the stage name of Matilda Alice Powles. She made her first appearance on stage at the age of three and went on to be a major music hall star. She was best known as a male impersonator and principal boy in pantomime – Burlington Bertie 'who rises at 10.30', was one of her most popular characters. During the First World War, she encouraged young men to sign up, earning her the nickname 'Britain's best recruiting sergeant'.

Vesta Tilley as
Burlington Bertie.

Fred Karno's Army

In 1903, Fred Karno's 'very clever band of comedians' presented *The Daddy Thieves* – a 'musical and whimsical burlesque' – at the Empire Palace. Fred Karno (1866 –1941) was the stage name of Frederick John Westcott. Karno developed slapstick comedy routines in the 1890s, which helped young comedians, among them Charlie Chaplin, and Chaplin's understudy Arthur Stanley Jefferson (who changed his name to Stan Laurel), rise to fame as part of his company. His name was immortalised by troops in the First World War with the song 'We Are Fred Karno's Army':

We are Fred Karno's Army,
A Jolly lot are we,
Fred Karno is our Captain,
Charlie Chaplin our O.C.
But when we get to Berlin,
The Kaiser he will say,
'Hoch! Hoch! Mein Gott,
What a jolly fine lot
Are the boys of company C.'

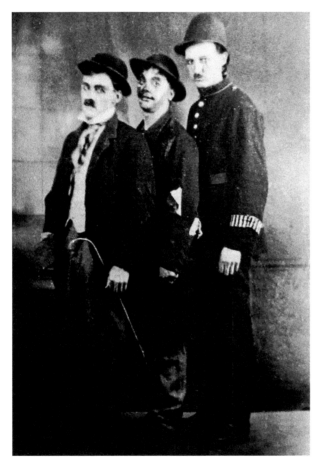

Charlie Chaplin as part of Fred Karno's troupe.

Pantomimes at the Empire Palace

The early Empire Palace pantomimes were particular favourites with Edinburgh audiences.

In December 1893, the Empire Palace produced its first Christmas spectacle, *A Harvest Home* – a 'delightful children's spectacle' that combined 'melodious music and an abundance of exceedingly clever dancing'. In 1894, this was followed by a similar festive production, *Topsy in Toyland*.

In 1895 and 1896, Oscar Barrett's 'refined musical pantomime' *Cinderella* was presented at the Empire Palace. Oscar Barrett (1846–1941) produced pantomimes of the highest quality at both the Crystal Palace and the Olympic Theatre in London. His productions had no trace of 'music-hall business' and were hailed as 'perfect examples of the genre' that brought an air of refinement to his 'fairy extravaganzas' (his preferred alternative name for his panto productions). He 'relieved the Christmas amusement from the slightest suspicion of vulgarity while remaining a good friend to the children, having done much to make pantomime a source of wonder, amazing delight and pure fun'. Barrett is also credited with being the first to introduce an interval in his pantomime production of 1893 at the Lyric Theatre – prior to that pantomimes were watched in a single sitting. Barrett's productions were hailed as revolutionary – they did not catch on, but left a lasting effect on the quality of pantomime.

In 1897, the Empire Palace produced its first pantomime on traditional lines – *Little Boy Blue*. This mixed a range of nursery rhyme characters – Bo Peep, Mother Hubbard, Babes in the Wood – and played to packed audiences.

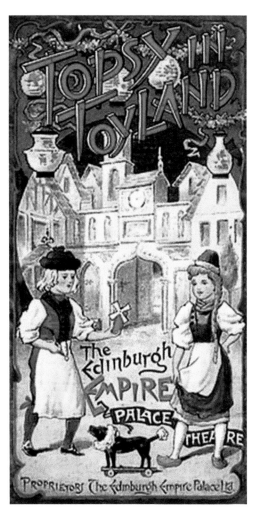

Playbill for *Topsy in Toyland.*

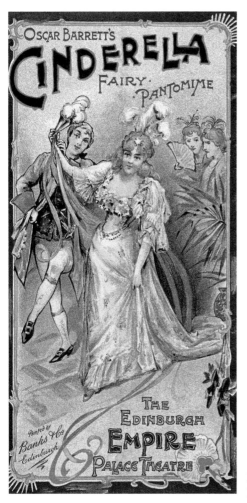

Flyer for Oscar Barretts's *Cinderella* at the
Empire Palace Theatre in 1895.

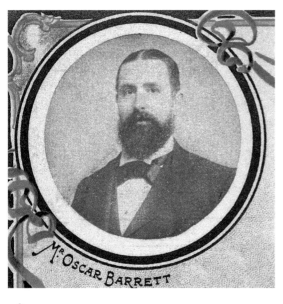

Oscar Barrett.

The pantomime production of *Babes in the Wood* over the 1899–1900 festive season at the Empire Palace included an all-female cast, with Miss Jennie Armstrong as Principal Boy and a band of twenty female 'merry men'. At this time the casting was more than likely a publicity ruse rather than a triumph for female equality.

First Cinema Show in Scotland at the Empire Palace

The Empire Palace has a distinguished place in the history of cinema in Scotland as the first venue in the country where moving pictures were shown. The date was April 13 1896 when cinematographe equipment developed by the Lumiere Brothers was used to project animated images during a variety show at the theatre. Despite the local newspaper reporting that 'the exhibition somehow missed fire' and the audience were more engrossed in the live variety acts rather than the flickering short films, a further two weeks of cinema shows were staged in June of the same year.

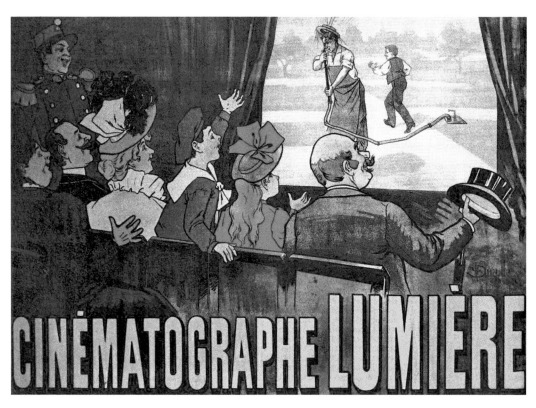

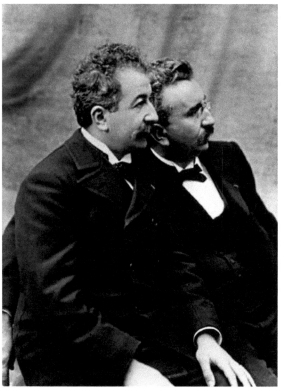

Above: Poster for the Cinematographe Lumière.

Left: Auguste and Louis Lumière.

Sigmund Neuburger, whose stage name was The Great Lafayette, was born in Munich, Germany on 25 February 1871 and moved to the States at the age of nineteen. Lafayette started his career as an illusionist in Vaudeville. When he arrived for a two-week season at the Edinburgh Empire Palace in May 1911 he was the most famous magician in the world and one of the most popular and highest paid entertainers of the early twentieth century.

Lafayette's mystifying illusions and elaborate quick-changes were presented in the most lavish and spectacular act ever seen in the music halls, but his season at the Empire Palace was to prove extraordinary even by his standards.

Lafayette had an eccentric lifestyle. He lived as a bachelor recluse with a small crossbred terrier, named Beauty, which had been given to him by Harry Houdini. The dog slept on velvet cushions, dined at the table with Lafayette and had a collar of pure gold studded with diamonds. The radiator ornament on Lafayette's limousine was a metal statuette of the dog. His London home and private railway carriage even had special rooms for Beauty, fitted with dog-sized settees and miniature porcelain baths. A plaque over the entrance to Lafayette's London home was inscribed, 'The more I see of men; the more I love my dog.'

Lafayette's spectacular show opened to packed houses at the Empire Palace on 1 May 1911. On 4 May, Beauty died of apoplexy, caused by over-feeding. Lafayette was grief-stricken, and had the dog laid out on a silk pillow surrounded by lilies in his room at the Caledonian Hotel. Lafayette then had Beauty embalmed and was given permission to have the dog interred at Edinburgh's Piershill Cemetery, with the strict provision that he agreed to be buried in the same place.

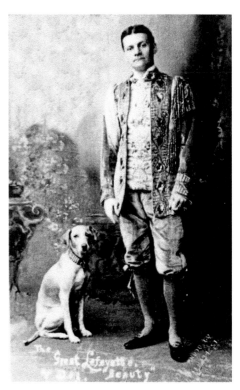

The Great Lafayette and Beauty.

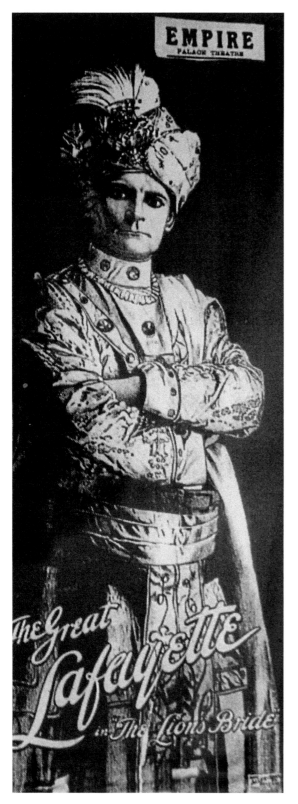

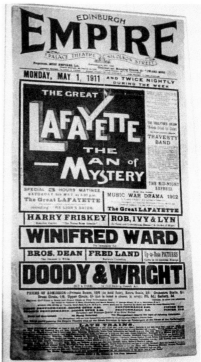

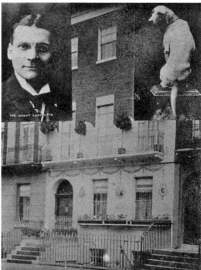

Left: The Great Lafayette in costume for his performance at the Empire Palace.

Top right: Playbill for Lafayette's show at the Empire Palace.

Above: Lafayette, Beauty and his house in London.

Meanwhile the show went on. On Tuesday 9 May, the Empire Palace was packed for Lafayette's second evening performance. Lafayette's act was the finale of the show. He entered, to a trumpet fanfare, dressed in a satin costume and proceeded to shake dozens of birds from a sequined cloth, finally producing a goat from the folds of the material. His act continued with other spellbinding illusions and elaborate scenarios in which he demonstrated his astounding quick-change routines.

The act ended with Lafayette's thrilling signature piece, 'The Lion's Bride', which involved the use of tapestries, cushions, tents and curtains to create an Oriental setting. A lion paced restlessly in a cage while fire-eaters, jugglers and contortionists performed. A young woman in Oriental dress walked slowly on stage and entered the cage. When she was inside, the lion roared and reared up ready to pounce. The animal's skin was then suddenly ripped away to reveal the Great Lafayette, who had miraculously changed places with the lion.

As the Great Lafayette took his bow, a lamp fell among the scenery, which instantly caught fire. A mass of flame shot over the footlights to the stalls. The audience, accustomed to the unusual light effects in Lafayette's act, were slow to recognise the danger. The fire curtain was rapidly lowered and the band began to play the national anthem, 'with a sheet of flame pouring into the auditorium above their heads'. This signalled the end of every theatre performance and brought the audience to their feet. They began to move towards the exits and, 'while there was crushing and some danger of being trampled', the entire audience managed to escape unharmed. However, by this time the backstage was an inferno. It was said that Lafayette had insisted that all the backstage doors were locked to prevent rivals sneaking in to see the secrets of his illusions and to ensure that the lion could not escape. Air passing through a gap at the bottom of the safety curtain also fanned the flames backstage. The fire brigade arrived on the scene in full force shortly after the outbreak and it took three hours to bring the fire under control.

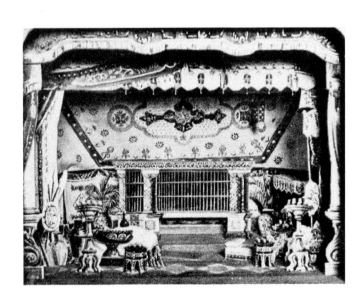

The Lion's Bride set.

33

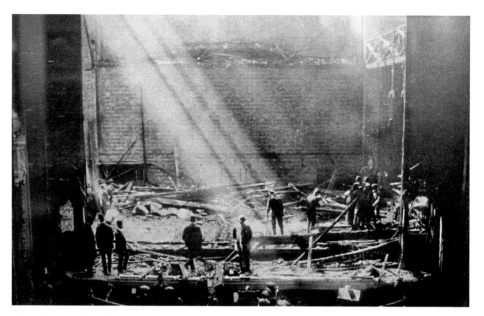
The aftermath of the fire.

Eyewitness reports claimed Lafayette had escaped and was outside the theatre for around forty minutes, but had returned in an attempt to save his horse. There were reports that his horse had been shot in the head, confirming that Lafayette had ended the animal's suffering.

Ten bodies were initially found in the backstage area, including James Edward Baines, John Whelan and Walter Scott, musicians in Lafayette's band; Joseph Coats and Alexander Rae Ross, flymen; James Watt, a scene shifter; a thirteen-year-old boy known as Little Joe; and Alice Dale, a tiny fifteen-year-old girl who operated a scene-stealing mechanical teddy bear. A lion and horse, part of Lafayette's, act were additional fatalities.

A charred body, burned beyond recognition, dressed in remnants of Lafayette's costume, was found near the stage. However, it was noted that the body was not wearing Lafayette's distinctive rings. A further search of the area below the stage a few days later revealed another body, this one with the diamond rings that Lafayette always wore. The first body was an assistant named Richards one of the doubles that Lafayette often used in his act.

A veil of grey mist hung over the city on the day of Lafayette's funeral, on 14 May 1911. The streets of Edinburgh were thronged with what was estimated at a quarter of a million spectators to see Lafayette's ashes moved from the funeral parlour of W. T. Dunbar in Morrison Street to Piershill Cemetery – his body had been cremated at the Western Necropolis in Glasgow as Edinburgh had no crematorium at the time. Mounted policemen were required to control the huge crowds that maintained an impressive silence until the last coach had disappeared and the blinds of the Caledonian Hotel, where Lafayette had stayed during his visit to Edinburgh, were drawn in respect. Street vendors sold memorial cards with a verse of poetry, and photographs of the illusionist and of the burnt-out stage at the Empire Palace.

**IN MEMORY OF
THE GREAT LAFAYETTE
(ILLUSIONIST)
WHO PERISHED
ALONG WITH MEMBERS
OF HIS COMPANY IN THE
EMPIRE PALACE OF VARIETIES
FIRE ON 9th MAY 1911**

DONATED BY W.T. DUNBAR & SONS

A commemorative plaque at the theatre near the spot where Lafayette's body was found was erected by the funeral directors W. T. Dunbar.

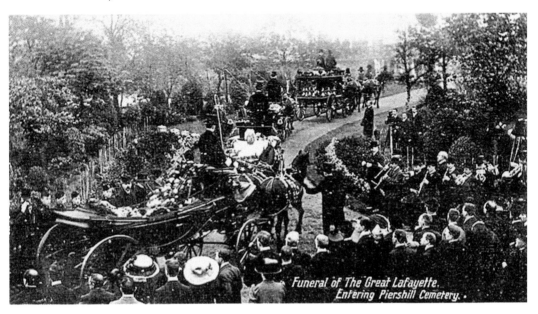

Lafayette's funeral procession at Piershill Cemetery.

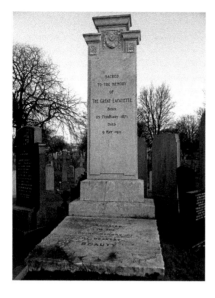

The grave of the Great Lafayette and Beauty at Piershill Cemetery.

The funeral was described as 'one of the most extraordinary internments of modern times'. The first car in the cortege of twenty carriages was the hearse, which was drawn by four fine horses with nodding black plumes. Then came seven carriages with floral tributes, followed by Lafayette's silver-grey Mercedes, the sole passenger in which was Mabel, a Dalmatian hound and one of Lafayette's favourites. This was followed by the mourners, including Lafayette's brother – who had travelled from Paris to attend the funeral. Lafayette's band joined the procession at Jock's Lodge and played Chopin's Funeral March.

There was great ceremonial at the cemetery, as Beauty's coffin was opened and Lafayette's ashes placed beside the dog. Harry Houdini sent a floral representation of Beauty to the funeral. Lafayette's grave, with a memorial stone to Beauty, can be seen on a grassy mound just inside the Portobello Road entrance to Piershill Cemetery.

A fatal accident inquiry into the disaster was held on 15 June 1911. This was assisted by a complete model of the stage with the *Lion's Bride* set. Mr Pordage, the chief of the Edinburgh Fire Brigade, considered that the available exits from the theatre were sufficient – there was no mention of doors being locked to protect the secrets of the act. He suggested that the death of James Edward Baines was due to a gallant effort to save the 'midgets' who had gone to the dressing rooms.

After hearing all the evidence the jury reached the verdict that that there was no negligence, but recommended that in future the city authorities should exercise more scrupulous care in regard to the safe construction of theatres and more frequent examination of water hydrants. The fire resulted in the universal rule that a building used for public entertainment should be designed to be evacuated in 2½ minutes in the event of a fire – which coincided with the time it takes for a band to play the national anthem.

The ghost of the Great Lafayette reputedly haunts the theatre to this day, and a seat in the upper circle, where the ghost has been seen, is upholstered in distinctive red velvet. In May 2011, the Edinburgh Festival Theatre hosted the Great Lafayette Festival, featuring magician Paul Daniels, to commemorate the hundredth anniversary of the tragic fire.

The disaster shocked the theatrical world. Sir Edward Moss' health deteriorated after the fire and he died on 25 November 1912 at his Middleton Hall estate in Gorebridge.

The restoration of the theatre was carried out by Frank Matcham. The stage and the dressing rooms suffered most in the fire, and the opportunity was taken to construct a new stage using up-to-date fireproof construction. An improved fireproof curtain was installed and fire resisting, smoke-tight doors. Although the auditorium escaped the worst of the fire, new chairs were installed and balcony fronts, pillars and boxes decorated with a new Oriental design in pale blue, white and gold.

Arrangements were made with Howard and Wyndham for the business of the Empire Palace to be carried out at the Theatre Royal on Broughton Street for the three-month period that it was closed. The theatre reopened in August 1911. However, it took some time for it to regain its status with performers and audiences.

A Command Performance Cancelled

Dear Sir Edward Moss, I have had the honour of submitting to the King and the Queen the request that their Majesties will be pleased to command a music hall performance during the coming season, either in London or Edinburgh as may be suitable to their Majesties' convenience. I am, in reply, to express their Majesties' thanks for this very kind proposal, and to say that, while existing and unalterable arrangements do not admit of such an entertainment taking place before their Majesties in London, the King and Queen will have great pleasure in being present at a command music hall performance in Edinburgh during their visit in July next.

Letter of 29 March 1911 from Buckingham Palace

King George V and Queen Mary.

The fire happened just weeks before the theatre was due to host the first Royal Command Variety Performance as part of the coronation celebrations, in the presence of their Majesties King George V and Queen Mary. A letter to Sir Edward Moss from Buckingham Palace, dated the 15 May 1911, passed on King George's condolences following the 'terrible fire' at the Empire Palace. The letter indicated that the King had not abandoned his intention of attending a music-hall entertainment and hoped that such a performance might be given at a later date. The Royal Command Variety Performance was held at the Palace Theatre in London on 1 July 1912.

It was around ninety years before the theatre finally hosted what was to be the first Royal Variety Performance in Scotland. On 24 November 2003, the Festival Theatre presented a cast that included Ronnie Corbett, Donny Osmond, Gloria Estefan, Westlife and Luciano Pavarotti in the presence of the Queen and the Duke of Edinburgh.

There have been numerous Royal visits to the theatre over the decades. Perhaps the most significant was on the 1 December 1936, when Prince Albert of York attended a charity performance in aid of the Orphan Fund of the Grand Lodge of Scotland and the Princes Margaret Rose Hospital at the Empire Theatre. The Prince having been told the shocking news that his brother King Edward VIII was abdicating to marry Wallis Simpson and that he would be assuming the monarchy as George VI.

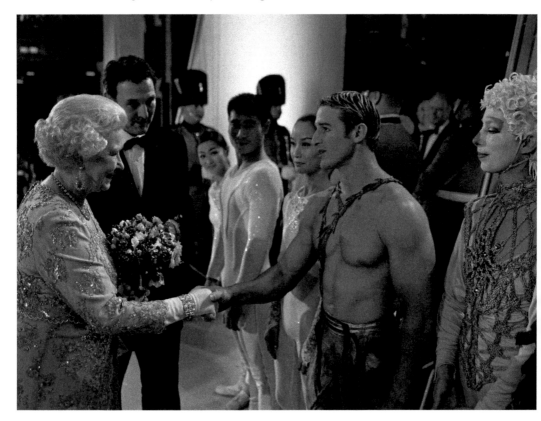

The Queen meets cast members on the stage of the Festival Theatre after the Royal Command Variety Performance in 2003.

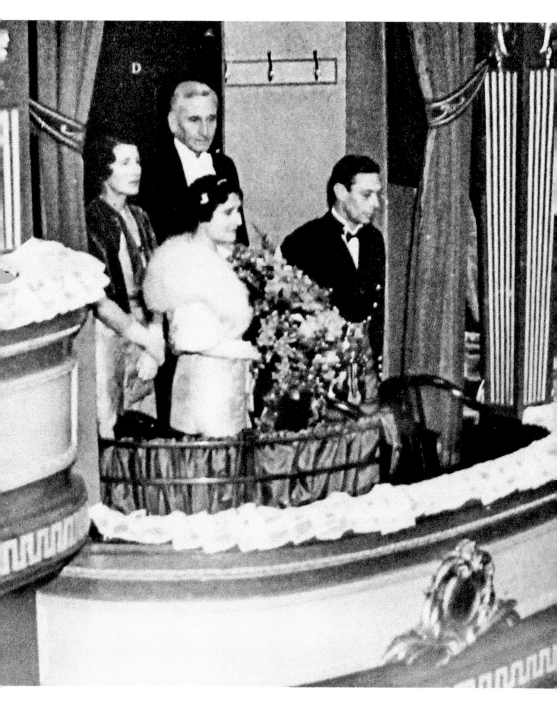

The Duke and Duchess of York at the Empire Theatre on 1 December 1936.

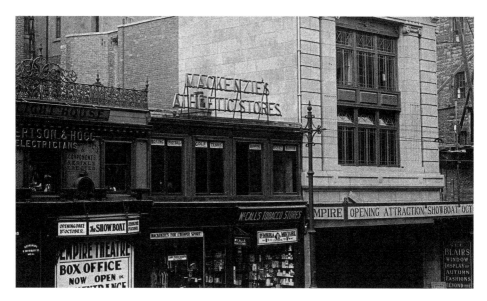

The Empire Theatre ready for its opening night.

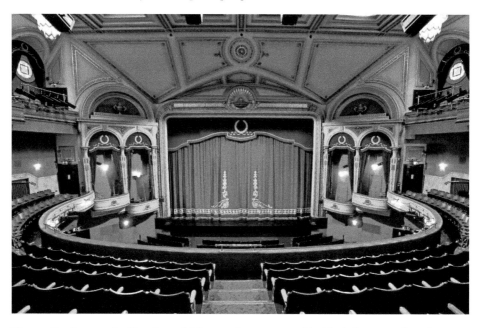

The auditorium at the Empire, which remains preserved behind the new glass frontage of the Festival Theatre. The boxes did not provide the best view of the stage; however, they were expensive and gave those that could afford them the chance to be seen by the audience. The decoration includes plaques above the boxes inscribed, 1928 and 1994 to mark the date of the auditorium and the 1994 reconstruction.

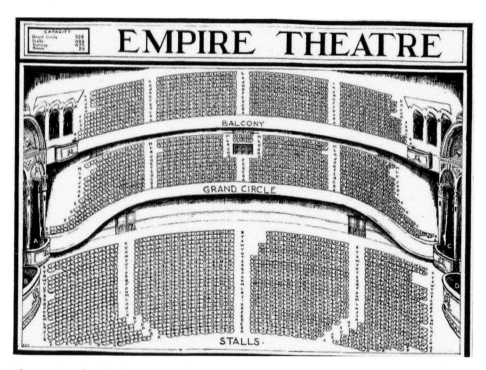

The seating plan for the Empire Theatre in 1928. The total capacity was 2,016.

William and Thomas Milburn. The Empire auditorium is their best surviving work.

By 1927, the Empire Palace was beginning to look unfashionable and was suffering from competition from the development of cinemas. In November 1927, the theatre closed and was largely rebuilt to a design by the prominent theatre designers William and Thomas Milburn, who were closely associated with the Moss Empire chain. Their design was less ostentatious than Matcham's and provided an auditorium with a capacity of just over 2,000. The new Empire Theatre (the word Palace was dropped from the name), with its art deco façade, reopened on 1 October 1928 with a three-week run of Jerome Kern's and Oscar Hammerstein's musical, *Show Boat*.

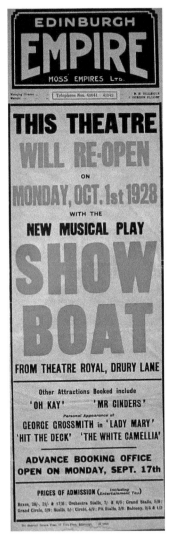

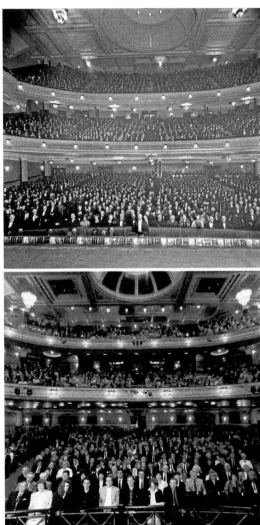

Above left: *Show Boat* poster from opening night of the Empire.

Above right: The opening-night audience at the Empire Theatre for the performance of *Show Boat* on 1 October 1928, and the audience at the opening of the Festival Theatre in 1994.

Variety at the Empire

In August 1933, the Empire reopened after the summer vacation with a new decorative scheme, improved acoustics and lighting. Since the reconstruction of the theatre in 1928, there was an impression that the auditorium suffered from a 'spacious coldness'. Experts in colour advised on a new paint scheme in rose and amber, which created an 'extraordinary optical illusion' making the theatre look cosier and more intimate. The acoustics, which had been the subject of complaints, were improved by the addition of five microphones on stage, and the limelight was increased in brightness.

A new programme and pricing policy were also introduced at the time of the 1933 refurbishment – the aim was to provide twice-nightly variety, revue and musical shows at prices that would compete with the talkies.

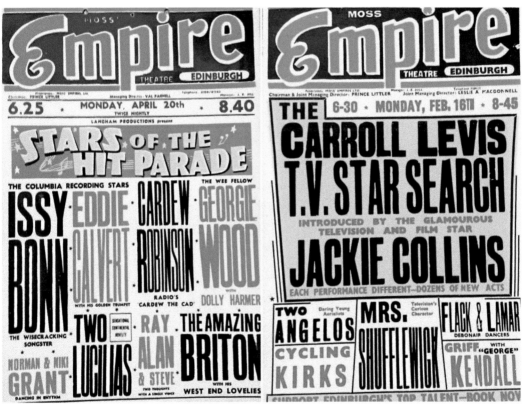

Empire Palace posters from 1953 and 1959 which illustrate the range of acts that appeared at the theatre during the 1950s. Many of the performers listed are long forgotten – over the decades for every entertainer that has made their mark, there are scores that, while good acts in their day, are now obscure. Eddie Calvert was a trumpet player who topped the charts twice in the 1950s; the small in stature Wee Georgie Wood was a veteran music hall and variety star; Cardew Robinson ('Cardew the Cad'); the ventriloquist, Ray Alan, who found fame with the puppet Lord Charles; and Jackie Collins, the sister of Joan, who became a successful novelist.

The theatre specialised in lavish variety shows featuring celebrity entertainers of the day – Max Wall, Morecambe and Wise, Harry Worth, Judy Garland, Tony Hancock, Tommy Cooper, Max Wall, Jack Buchanan, and big bands such as Joe Loss were just some of the stars of light entertainment that treaded the boards of the Empire.

Jimmy Hill

James (Jimmy) Hill was the general manager of the Empire during its heyday as a Variety theatre and was Mr Empire to a generation of music-hall-goers. After leaving school he pursued an apprenticeship in law for a short time until the thrills of conveyancing began to pall and, seeking a more Bohemian way of life, he became associated with the theatre, joining Moss Empire as a clerk at the Edinburgh Empire in 1913. After service in the First World War, he rejoined the Empire as assistant manager and was promoted to manager in 1931.

If any performers included what he considered suspect material in their act, he was known to visit their dressing room to let them know that the content had to be toned down for the Edinburgh audience. Jimmy was also able to recount a story about Harry Lauder ordering a beer at the theatre bar. When a small amount of froth spilled onto the counter, Lauder asked the barmaid to give him another. When Jimmy asked Lauder why he had done that, the response from Lauder was, 'Hush, dae ye no' realise that story will be a' ower the city the morn.'

Jimmy requested a signed photograph from every act that appeared at the Empire and his priceless collection, which is now on display in the Empire Room of the Festival Theatre, represents an impressive cross-section of theatre and music hall performers.

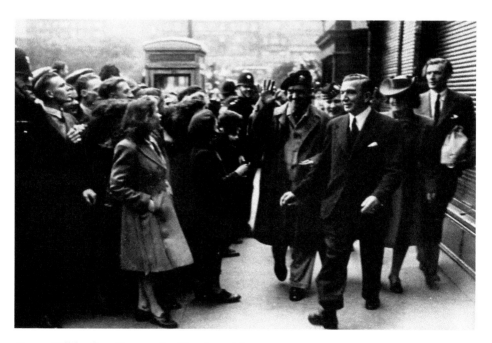

Jimmy Hill leading the way for Stan Laurel in 1954.

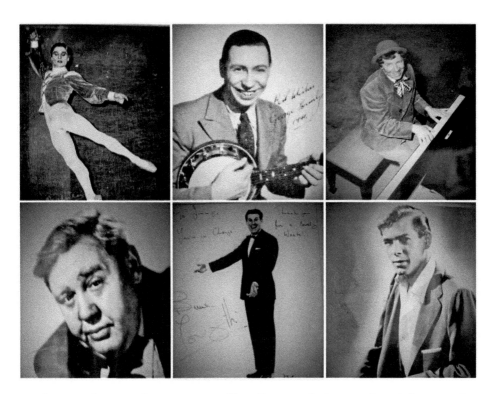

A selection of images from Jimmy Hill's collection of photographs of the stars that appeared at the Empire – Rudolf Nureyev, George Formby, Chico Marx, Charles Laughton, Bruce Forsyth and Johnnie Ray.

Laurel & Hardy

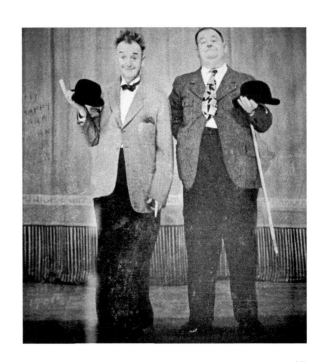

Signed photo of Laurel & Hardy presented to Jimmy Hill.

45

The Empire with an advertising display for Laurel & Hardy's week-long show starting on 12 April 1954.

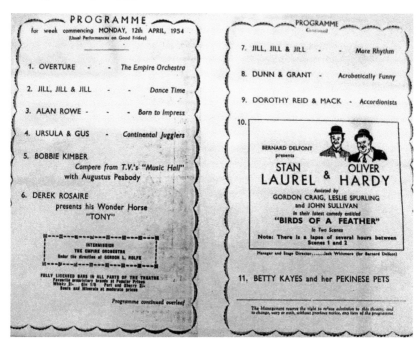

PROGRAMME

for week commencing MONDAY, 12th APRIL, 1954.
(Usual Performances on Good Friday)

1. OVERTURE - - The Empire Orchestra

2. JILL, JILL & JILL - Dance Time

3. ALAN ROWE - - Born to Impress

4. URSULA & GUS Continental Jugglers

5. BOBBIE KIMBER
 Compere from T.V.'s "Music Hall"
 with Augustus Peabody

6. DEREK ROSAIRE
 presents his Wonder Horse
 "TONY"

INTERMISSION
THE EMPIRE ORCHESTRA
Under the direction of GORDON L. ROLFE

FULLY LICENSED BARS IN ALL PARTS OF THE THEATRE
Favourite proprietary brands at Popular Prices
Whisky 3/- Gin 1/9 Port and Sherry 2/-
Beers and Minerals at moderate prices

Programme continued overleaf

PROGRAMME
Continued

7. JILL, JILL & JILL - More Rhythm

8. DUNN & GRANT - Acrobatically Funny

9. DOROTHY REID & MACK - Accordionists

10.

BERNARD DELFONT
presents

STAN OLIVER
LAUREL & HARDY
Assisted by
GORDON CRAIG, LESLIE SPURLING
and JOHN SULLIVAN
In their latest comedy entitled
"BIRDS OF A FEATHER"
In Two Scenes
Note: There is a lapse of several hours between
Scenes 1 and 2

Manager and Stage Director.....Jack Whitmore (for Bernard Delfont)

11. BETTY KAYES and her PEKINESE PETS

The Management reserve the right to refuse admission to this theatre, and
to change, vary or omit, without previous notice, any item of the programme

Programme for Laurel & Hardy's 1954 show at the Empire.

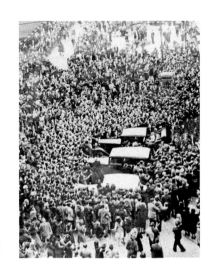

Thousands of adoring fans blocked the streets of Edinburgh to give Laurel & Hardy a rapturous welcome in April 1954.

The world's most famous comedy double act, Stan Laurel and Oliver Hardy, first visited Edinburgh for shows at the Playhouse Cinema in 1932. They played to packed audiences at the Empire on subsequent visits in 1947 and the early fifties. Stan Laurel has a strong Scottish connection: his father managed Glasgow's Metropole Theatre and he gave his first performance on stage at the Panopticon in Glasgow.

Roy Rogers and Trigger

Roy Rogers, the King of the Cowboys, created quite a stir in Edinburgh when he appeared with his 'four-legged friend' Trigger at the Empire in February 1954. Roy and Trigger were major stars at the time and were mobbed by the young fans of their Li'l Pardners Club. Rogers stayed at the Caledonian Hotel with his wife Dale Evans, the Queen of the Cowgirls, and on one occasion rode up the stairs of the hotel on Trigger. Roy and Dale also visited a local children's home and were so charmed by a young girl called Marion Fleming that they invited her to stay with them in California and she became part of the Rogers family.

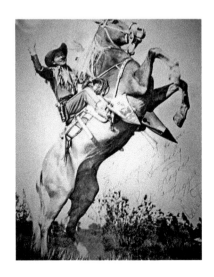

Roy Rogers and Trigger.

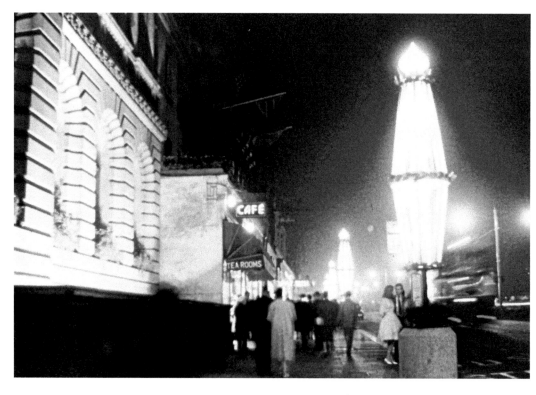

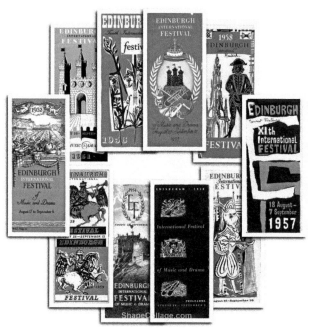

Above: Princes Street decorated for the Edinburgh International Festival in 1959.

Left: Early Festival programmes.

48

In August, Edinburgh welcomes thousands of performers and visitors for the three weeks of the Edinburgh International Festival of Music and Drama – the greatest arts event in the world, when Edinburgh is host to the best in music, opera and drama.

Rudolf Bing, manager of the Glyndebourne Opera House, first conceived the ambitious idea of a festival to revitalise cultural activities following the dark and austere times of the Second World War. The intention was to lead people towards a new way of life through the common enjoyment of the best in music, drama, and art.

Bing visited a number places hoping to establish a home for his arts festival, but received little encouragement. Edinburgh was much more responsive and fortunate that Sir John Falconer, the Lord Provost at the time, recognised the value that the festival would bring to Edinburgh, and he promoted the advantages of Edinburgh as a home for the event.

The first festival was modest, but, a major act of faith in the austerity of post-war Britain. It opened on Sunday the 24 of August 1947 and in its first year was visited by Her Majesty the Queen (Queen Elizabeth), the Queen Mother and by Princess Margaret. Glyndebourne Opera presented *The Marriage of Figaro* and *Macbeth*, the Vienna State Orchestra played, the Sadlers Wells Ballet performed, Kathleen Ferrier sang and Alec Guinness appeared in *Richard II*.

The Empire, and in its later guise as the Festival Theatre, was a prime venue from the start of the Edinburgh International Festival. The theatre has been predominantly linked with festival ballet and, during the first Festival in 1947, Dame Margot Fonteyn, one of the greatest ballet dancers of all time, appeared in *The Sleeping Beauty* – although, in line with the theatre's variety tradition, Val Doonican also performed during the first Festival. In the following years, the Old Vic Theatre Company, the Royal Ballet and the Royal Opera were also featured.

Bingo at the Empire

Television was first introduced in Scotland in 1952, and by the end of the fifties most homes had a TV in the corner of a room. The increasing popularity of television meant that it was no longer necessary to leave home for a night's entertainment. This resulted in dwindling audiences for theatres, which made it difficult for many venues to survive into the 1960s.

In 1962, the Empire closed, was sold to Mecca for £165,000 and by March 1963 reopened as the New Empire Casino to cater for the new fad of bingo. Mecca removed the seats in the stalls, but kept the building in good repair.

Theatrical productions continued at the bingo hall during the Festival and it was an important venue for rock concerts – Black Sabbath, Deep Purple, Jethro Tull, T-Rex, Free, Roy Harper, Elton John, Lindisfarne, Hawkwind, Slade, Captain Beefheart, Status Quo, Roxy Music and The Ramones performed at the theatre during its time as a bingo hall. David Bowie appeared on the 6 January and the 19 May 1973, at the height of his hugely popular Ziggy Stardust persona.

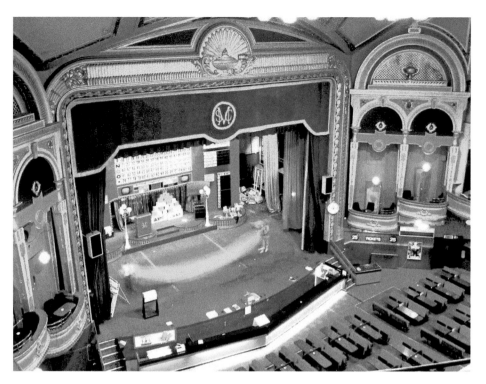

The auditorium of the Empire fitted out for bingo.

Old advert from the golden age of bingo.

We wanted a name which would reflect the high quality of the project and its international status. By changing the name I hope we have also highlighted the fact that there is a new addition to the city's artistic infrastructure, one which will enhance and develop Edinburgh's international reputation.

<div style="text-align: right">

Lord Younger in 1991, announcing the proposed renaming
of the Empire Theatre as the Festival Theatre

</div>

In 1992, bingo was falling out of favour and Mecca was having financial difficulties. At the same time, a search was on to find a prestigious venue for Festival productions. The building had been little altered during its time as a bingo hall and its potential for reuse as a theatre was recognised. The local authority negotiated the purchase of the building from Mecca and it was leased to the Edinburgh Festival Theatre Company, which was chaired by Lord Younger. The rebuilding was made possible by large grants from the local councils and Lothian & Edinburgh Enterprise Limited. Over £4 million was also donated by companies, trusts and individuals.

The conversion of the theatre was designed by the architectural firm Law & Dunbar-Naismith Partnership – Mecca, the operators of the bingo hall, were keen to keep the proposed conversion of the building a secret and Sir James Dunbar-Naismith was forced to take out a bingo club membership so that he could clandestinely survey it on bingo nights.

The conversion of the theatre ended the long campaign for an opera house, which began after the first Edinburgh International Festival in 1947 and had never progressed past the hole in the ground at Castle Terrace.

The final changes to the theatre were completed in June 1994, when it was dramatically transformed into the Edinburgh Festival Theatre – at the relatively modest cost of £21 million for a theatre of its scale and prestige.

The old frontage was replaced with a stunningly modern concave glass and steel façade enclosing a contemporary bar and foyer spaces. The backstage was rebuilt with dressing rooms for 180 artists and 80 fly lines. The new 25-metre-by-18-metre mammoth stage was the largest in Europe at the time. Between the theatre's modern exterior and backstage, the superb 1928 auditorium was embellished and restored to its original grandeur and splendour.

The theatre reopened on 18 May 1994 under the management of Paul Iles. The first show, *Meet Me at The Empire*, featured the Krankies, Rikki Fulton, a pipe band and novelty acts. It was intended as a backward glance to the magic and vitality of the heyday of the theatre's early years as a variety venue. The show was loved by the capacity first-night audience, which vigorously applauded the acts. However, it met with some criticism for being too lowbrow. One Edinburgh councillor condemned the show as 'an insult to Scottish culture, which was not an appropriate way to open an international theatre'.

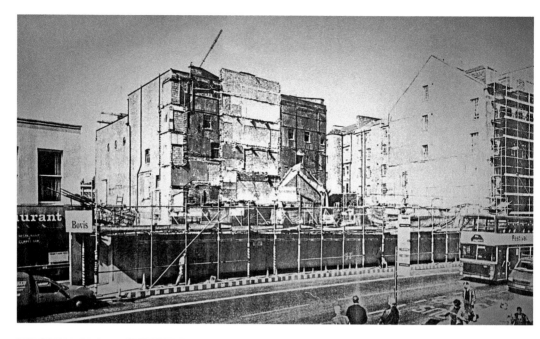

EDINBURGH FESTIVAL THEATRE

SHOW TIME: **SATURDAY 18 JUNE 1994 AT 8.00PM**

EDINBURGH FESTIVAL THEATRE TRUST

PRESENTS

MEET ME AT THE EMPIRE

THE FIRST NIGHT OF SCOTLAND'S NEW INTERNATIONAL OPERA HOUSE, LYRIC THEATRE AND GRAND PALACE OF VARIETIES

STARRING

RIKKI FULTON•THE KRANKIES

UNA McCLEAN•RUSSELL HUNTER
BRENDA COCHRANE•DEAN PARK

LOTHIAN AND BORDERS POLICE PIPE BAND
INTERNATIONAL PURVES PUPPETS of BIGGAR
THE THEATRE SCHOOL OF DANCE AND DRAMA, EDINBURGH
KENNEDY AITCHISON'S FESTIVAL THEATRE ORCHESTRA
THE DESIGN TEAM

DIRECTED BY **DOUGLAS SQUIRES**
MUSICAL DIRECTION BY **KENNEDY AITCHISON** • CHOREOGRAPHED BY **RAYMOND KAYE**
LIGHTING DESIGNED BY **ALAN CAMPBELL** • SCENIC ILLUSIONS BY **ALAN MILLER BUNFORD**
PRODUCED BY **PAUL ILES**, **NICK THOMAS** AND **JAMIE PHILLIPS**
STAGE MANAGEMENT BY **PETER ANDERSON**, **EUGENE ANDROSOV**, **MARK PYMAN**, **GRAHAM RAITH**,
OLIVER RECK AND **WILLIAM WARD**

Above: The site during its transformation into the Festival Theatre.

Left: Programme for the opening of the Festival Theatre on 18 May 1994.

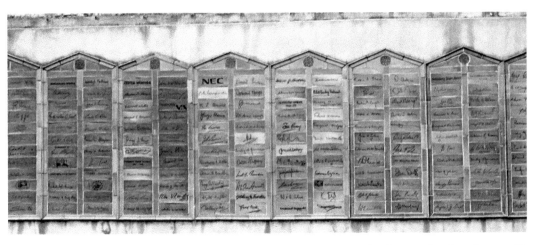

The wall of fame in the theatre courtyard consists of terracotta tiles designed and made as a gift to the theatre by the ceramics department at the Edinburgh College of Art. Each has been signed by a donor including Lord Menhuin, Jackie Stewart and Sean Connery.

It was first general manager Paul Iles' view that there weren't enough 'culture vultures' in Edinburgh to fill the theatre with opera and ballet all the year round, and that a varied programme of shows was an economic necessity to attract audiences. This was reflected in the next event in the theatre's programme, which was a gala performance of Wagner's opera *Tristan and Isolde*.

Paul Iles

Paul Iles (1952–2011) was the first general manager of the Festival Theatre from 1992 and was responsible for managing the conversion of the old Empire into the new venue. The opening-night bill reflected his approach to programming which mixed the popular with the more highbrow and avant-garde.

Iles reputedly started his theatrical career as a cleaner and went on to manage a number of theatres in Australia and England, before taking up the post at the Festival Theatre. He resigned from the Festival Theatre in 1996 and mixed a career as an academic with theatre consultancy.

His playful sense of humour and 'healthy immunity to the dictates of convention' are reflected in letters that he sent out during his time as manager of the Festival Theatre. This one is in response to a lady who complained that her daughter had snagged her skirt on a seat at the theatre:

Thank you for your letter. I am sorry that you do not accept that your daughter could have an accident in this theatre without it being our fault. If you do not gather your skirts properly as you sit down and stand up on a tip-up seat it is possible for them to become caught – in a fixed seat this is less likely to be the case. As I pointed out in my last letter, hundreds of thousands of people (including Her Majesty the Queen in a priceless ball-gown) have sat in these very seats since the year 1928 without incident and the theatre cannot accept responsibility for your daughter's accident. However, to show that we do feel sympathetic if not actually responsible I have pleasure in enclosing a complimentary voucher for two tickets – please ensure that she gets up and down from her seat very carefully.

Paul Iles.

Iles was very well respected in the theatre world and the Festival Theatre flag was flown at half mast in tribute at the time of his death in 2011.

The Edinburgh Festival Theatres Trust

The size of the theatre meant that it was difficult to fill and it soon ran into financial problems. A funding package was arranged with the local authority, and restructuring, including a 1997 merger with the King's Theatre, which had been sold to the local authority in 1969, also reduced overheads. Both theatres are now managed by the Festival City Theatres Trust.

The Festival Theatre is now one of the UK's leading venues and the best international performers from the worlds of dance, theatre and music have graced its stage including Glyndebourne, the Royal Shakespeare Company and the Kirov Ballet. It plays host to the Edinburgh International Festival, Scottish Opera, Scottish Ballet, the Edinburgh Jazz & Blues Festival and the Edinburgh International Film Festival.

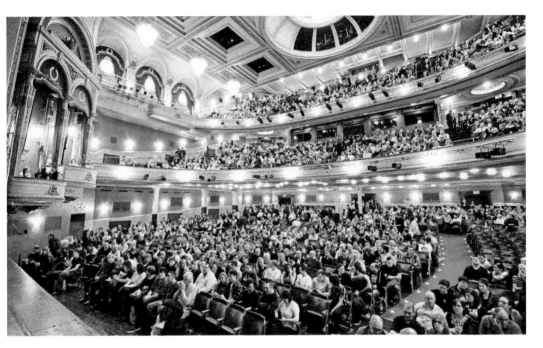

A busy house at the Festival Theatre.

The Festival Theatre Cinema

The Festival Theatre auditorium is equipped to show films and is the largest cinema in Scotland. The screen was first used for the opening of the 2010 Edinburgh International Film Festival with the premiere of *The Illusionist*. The theatre has since hosted a number of gala events and screenings as part of the Film Festival, most notably the UK premiere of the Disney Pixar hit *Brave*, and the simulcast of David Putnam's *Chariots of Fire*, screened as part of the London 2012 Festival.

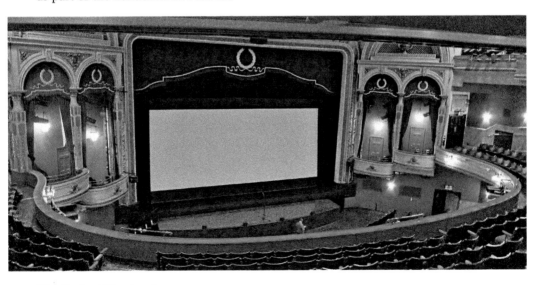

The Festival Theatre cinema.

Sir David Putnam at the Festival Theatre in 2012 for the screening of *Chariots of Fire*.

The Studio

The Festival Theatre's studio is an exciting multipurpose cultural resource for the city, which opened in 2013. Located behind the theatre on Potterrow, the studio is a flexible space that can accommodate for range of activities from rehearsals and workshops to small-scale performances and festivals.

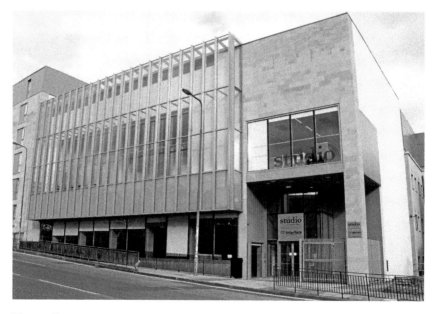

The studio.

Jessica Harrison's artwork, a *Spinal Column*, was installed in the Circle Bar at the Festival Theatre in 2004 to mark the quincentenary of the theatre's near neighbour, the Royal College of Surgeons.

The King's Theatre

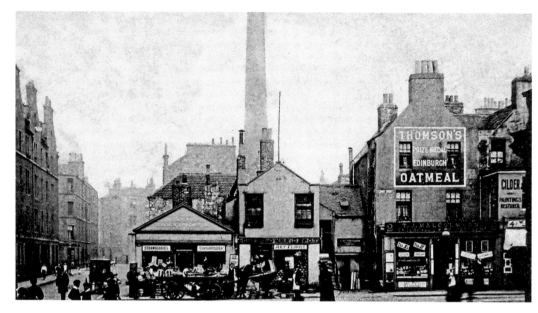

The site before the King's was built.

The Site

The prominent site at the corner of Leven Street and Tarvit Street for the construction of the King's was acquired in 1905. The original buildings on the site consisted of a group of retail outlets owned by Thomas J. Malcolmson, grocer and wine merchants, and the Drumdryan Brewery – the tall chimney of which can be seen in the photograph.

The Building of the King's

The King's was originally commissioned by the Edinburgh Building Company Ltd, a syndicate of local businessmen led by Councillor Robert C. Buchanan. Buchanan (1870–1935) was born Robert Colburn in Shettleston, near Glasgow. He was an actor from the age of sixteen and from 1894 was Professor of Elocution at Glasgow's Athenaeum in 1894. From 1900, he managed and opened a number of theatres.

Construction began in 1905 and a memorial stone, which occupies a conspicuous position on the marble staircase, was laid on Saturday 18 August 1906 by Andrew Carnegie. Copies of newspapers and some coins were placed under the stone.

The Edinburgh Building Company soon ran into financial difficulties and in 1908 offered the King's to the Howard & Wyndham Group for £35,000. Howard & Wyndham turned down the offer, as they already had two theatres operating in Edinburgh. Ownership was then transferred to the King's Theatre Company, the major shareholder which was William Stewart Cruikshank, a prominent Edinburgh builder and the contractor responsible for the construction of the theatre.

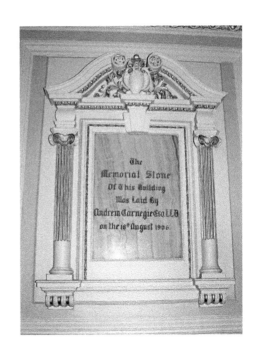

The King's memorial stone.

Buchanan was originally retained to manage the project, but was soon replaced by Cruikshank's son, Alexander Stewart Cruikshank, who was an enthusiastic businessman with a keen interest in theatre.

A. Stewart Cruikshank

From 1908, A. Stewart Cruickshank (1867–1949) was involved in the running of the King's and in 1911 he was made a director.

One of Cruickshank's most financially rewarding strokes of business was acquiring the rights for British performances of the enormously popular *Rose Marie*, which he saw on a business visit to the United States.

A. Stewart Cruikshank.

When the King's was merged with the Howard & Wyndham chain of theatres in 1928, Cruickshank became chairman of the group and was regarded as one of the most powerful men in the British theatre industry. Howard & Wyndham's AGMs were normally held on Christmas Eve at the King's – which ensured nominal intrusion by shareholders. Cruikshank introduced the successful summer variety seasons, which promoted Dave Willis to stardom.

Stewart Cruickshank,died in hospital on 8 December 1949 at the age of seventy-two, after he was knocked down by a motorcyclist in Murrayfield Avenue near his Edinburgh home. His son, Stewart, became managing director of Howard and Wyndham after his death and the link between Howard & Wyndham and the Cruikshank family continued into the 1970s.

Howard & Wyndham
The Howard & Wyndham theatre management company was founded in 1895. The creation of the company formalised the existing partnership between the actor-managers, John B. Howard and Frederick W. P. Wyndham, who were already running a number of theatres in Glasgow and Edinburgh. Further theatre development soon made the company one of the largest in the country, rivalling Moss Empires.

In the 1960s, Howard & Wyndham sold all of its theatres to the local city councils. The only exception was the Alhambra in Glasgow, which eventually closed in 1969.

Howard & Wyndham.

The Exterior of the King's Theatre

Two different architects were responsible for the design of the King's – James Davidson and J. D. Swanston. Davidson, a Coatbridge-based architect, took charge of the graceful symmetrical Edwardian Baroque red-sandstone exterior of the building with its neat double windows and ornate projecting central bay over the entrance. The façade reflects Davidson's experience in the design of solid civic buildings.

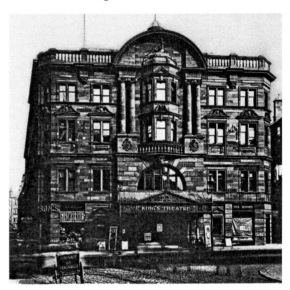

An early view of the King's.

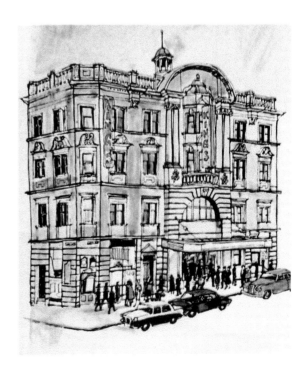

The King's in 1966.

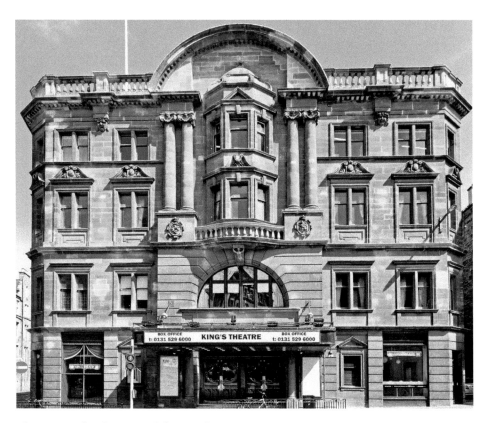

The present-day frontage of the King's.

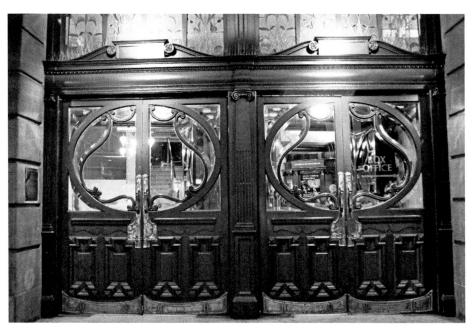

The sumptuously panelled glazed entrance doors with bevelled glass in swirling art nouveau frames.

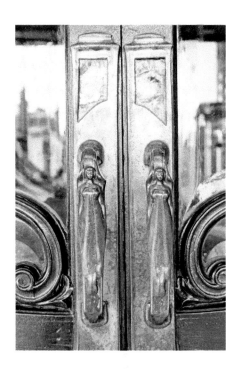

The elegant art nouveau brass door handles inlaid with enamel decoration.

Inside the King's Theatre

J. D. Swanston, a Kirkcaldy-based architect with experience of theatre design, was responsible for the flamboyant interior, which contrasts with the rather stern frontage.

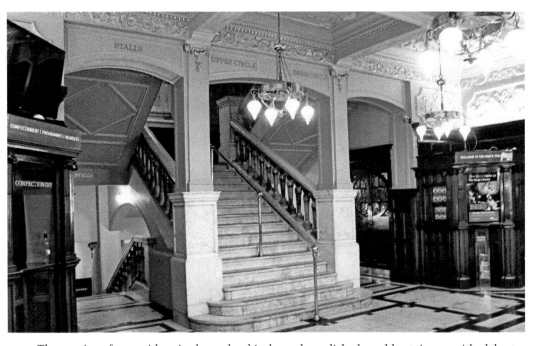

The spacious foyer with paired wooden kiosks and a polished marble staircase with alabaster balusters.

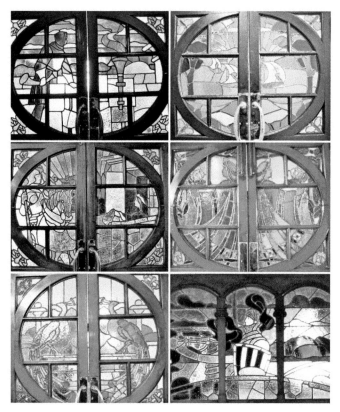

Left: Art nouveau-style stained-glass panels of the highest quality embellish the foyer and Circle Bar. The panels depict peacocks, Arthurian legend and girls with roses. The stained glass is probably by the Edinburgh-born designer and artist Stephen Adam (1848–1910) who founded a prosperous stained-glass business in Glasgow.

Below: The Circle Bar at mezzanine level with ornate doors each side.

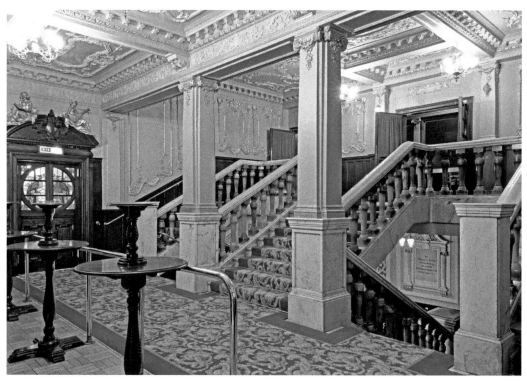

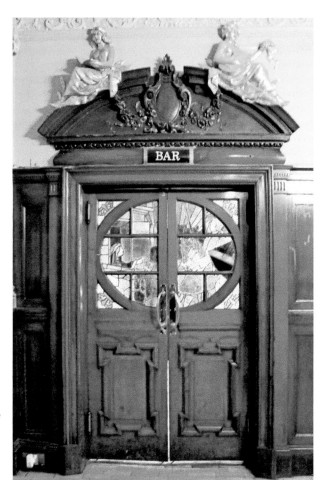

Right: Door detail at the Circle Bar with gilded female figures at each side of the ornate pediment.

Below: The oak-panelled directors' room on the third floor of the King's. The painting over the fireplace shows the Leven Street site before the theatre was built.

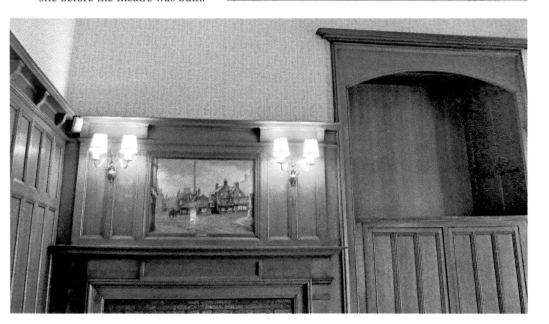

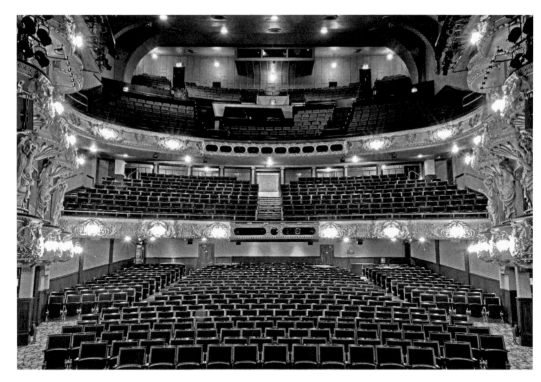

View from the stage at the King's.

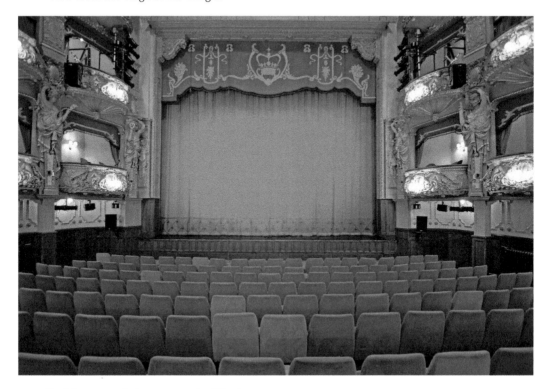

Looking toward the stage at the King's.

Right: The towering stacks of tiered boxes – nine each side over three levels.

Below: The boxes are sumptuously decorated with three-dimensional French Renaissance-style plasterwork. The fronts of the boxes are decorated with cherub figures, known as Putti, blowing trumpets. From ancient times instrument-playing Putti represented the sound and music emanating from the structures they decorated. The boxes are separated by voluptuous nudes representing music and the arts.

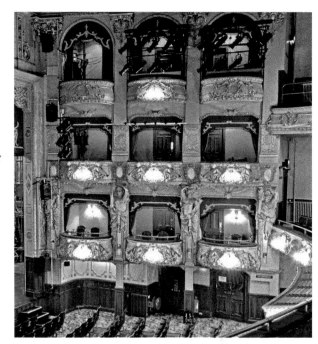

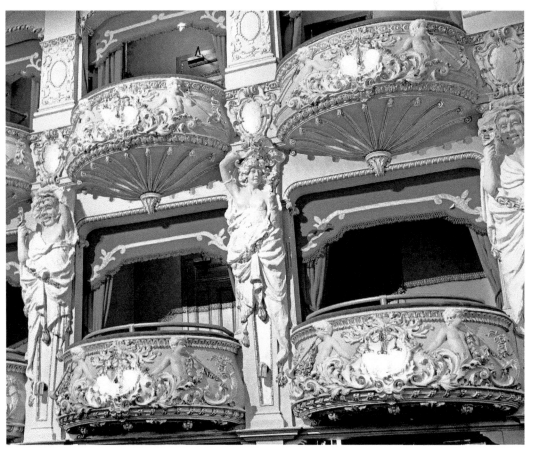

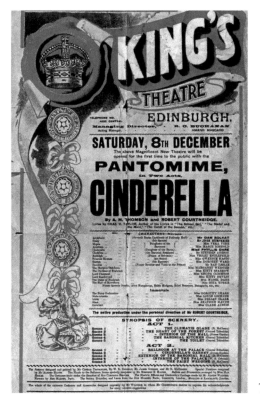

The opening-night programme at the King's.

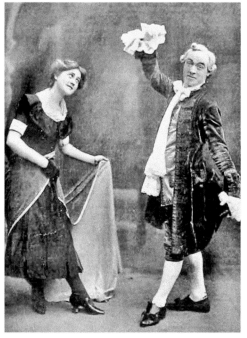

'Miss Phyliss Dare is now playing the familiar role of Cinderella at Edinburgh with great success. She is seen here in a stately dance with Mr Dan Roylat, who is playing the Baron.'
The Bystander, 16 January 1907

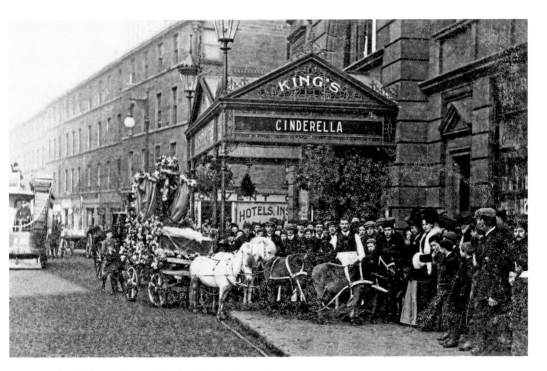

Cinderella's coach outside the King's in 1906.

The King's Theatre opened for the first time on 8 December 1906 with a festive production of the pantomime *Cinderella* with Violet Englefield as the Prince, the seventeen-year-old Phyllis Dare as Cinderella and Dan Rolyat as the Baron. Dare (1890–1975), Englefield (1881–1946) and Rolyat (1872–1927) were all well-known stars of Edwardian musical theatre. Rolyat was born Herbert Taylor, but reversed his surname to make it more distinctive.

It was reported that tickets were at a premium for the opening night and a large group of spectators had to be controlled by the police outside the theatre, which was brightly lit and decorated with hanging baskets. The interior 'charmed the eye with the artistic harmony of the decorations in rose and white and gold which alike under brilliant light and partial shadow, present an elegant appearance'.

The show opened with 'an elaborate wintry forest scene, which by the magic of the fairy god-mother's wand was transformed into a spring glade with a cascade of real water, where the dashing Prince first meets Cinderella'. The scene that was reported as having most appeal to the audience was when Cinders was dressed for the ball, which culminated in the entrance of an 'elegant little coach, sparkling with electric lamps and drawn by tiny live ponies'.

Miss Phyllis Dare is described as 'graceful and winsome with a sweet voice which made her a charming Cinderella'; Dan Rolyat 'made of the Baron an admirable comedy study' and Miss Violet Englefield made a 'dashing and hardworking Prince'.

There was great enthusiasm at the end of the show. Mr Courtneidge, the director, thanked the audience for the hearty reception and said that it had long been his ambition to produce a pantomime in his native city. Mr R. C. Buchanan, the managing director, said that it was the most memorable first night in his recollection and noted that he had received many telegrams of congratulations.

The King's quickly became established as a touring venue with regular visits from the Carl Rosa Opera and the Richard D'Oyly Carte Company, which had exclusive rights to perform Gilbert and Sullivan's operettas. The D'Oyly Carte Company's seasons at the King's were immensely popular with the 'magnetic powers of Gilbert and Sullivan' ensuring that there was not a vacant seat in the house. The 1930 season of the *Mikado* included Sir Henry Lytton, a leading exponent of Gilbert and Sullivan, as *Ko-Ko*.

The Promptitude of the Fire Brigade Saves the King's

On 11 July 1909, the King's had a narrow escape from a major fire. At seven in the morning a passer-by on Valleyfield Street noticed thick clouds of smoke coming from the upper windows. The caretaker was made aware of the fire, and when he entered the auditorium he was forced back by the choking smoke. The fire brigade was called and had the fire under control within half an hour. The dress circle and upper circle were badly damaged. The cause of the fire was found to be a match that had been dropped by a member of the audience and which had smouldered overnight. *The Scotsman* reported that the theatre only escaped destruction by the early discovery of the outbreak and the 'promptitude of the Fire Brigade'.

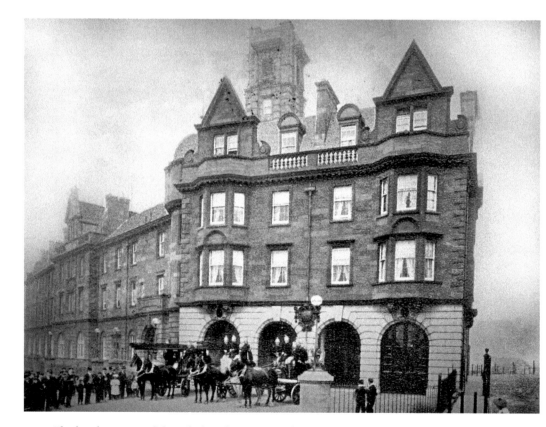

The headquarters of the Edinburgh Fire Brigade on Lauriston Place in 1905.

The headquarters of the Edinburgh Fire Brigade was on Lauriston Place, just round the corner from the King's, and would have allowed them to respond quickly to the fire at the theatre. James Braidwood (1800–61) established the world's first municipal fire service in Edinburgh in 1824. He was appointed Edinburgh's master of fire engines at the age of twenty-four, just before the Great Fire of Edinburgh, which raged for five days from the 15 November 1824 and destroyed a large part of the High Street from St Giles to the Tron. Braidwood introduced methods of firefighting that are still used today and is credited with the development of the modern municipal fire service. Braidwood died fighting the Tooley Street fire at Cotton's Wharf in London on 22 June 1861, when he was crushed by a falling wall.

Sir Harry Lauder

'Good old Harry,' cried an enthusiast at the King's Theatre last night when Lauder with that consummate art had taken a complete grip of the crowded audience and touched it to raptures. 'Thanks' said the comedian readily, and with a smile, "but cut out the old". Harry Lauder refuses to get really old; his genius does not dim. That is the quality that explains him, that answers the wonder of this little man's extraordinary success. His gift of song, his instinct for mimicry, his keen observation for the minute but telling touches of life, his abiding good fortune in the simple lilts that haunt the ear, are all individually his and his genius, that something more that is beyond parts and personality, threads them all into – Harry Lauder.

The Scotsman, 2 October 1928

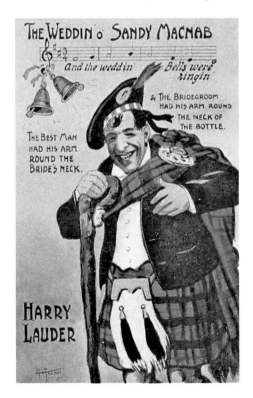

Caricature of Harry Lauder with kilt and crooked walking stick.

Portobello–born Henry McLennan Lauder – Harry Lauder (1870–1950) was a regular at the King's at the peak of his career in the early days of the theatre. Lauder was an international star, one of the country's best-loved entertainers and the highest paid performer in the world. He projected a nostalgic image of Scotland, taking to the stage in full Highland dress with a crooked walking stick. This theme was reflected in self-penned songs such as 'I Love a Lassie', 'Roamin in the Gloamin', and 'A Wee Deoch-an-Doris'. Lauder was knighted in 1919 for his tireless work organising entertainment for the troops during the First World War. A plaque, presented by the British Music Hall Society in the foyer of the King's, commemorates Lauder's long association with the theatre.

We Never Close

The King's doors never closed during the two World Wars and hosted special soldiers' nights for the troops. In March 1915, the Second Line of the 9th Royal Scots and their friends filled the building for a programme that was specially arranged for their entertainment, with contributions from members of the Battalion. The night was described as an unqualified success, the theatre filled with the 'lusty choruses' of the troops.

Private Lives Premiere

The premiere of Noel Coward's *Private Lives* was held at the King's Theatre on 18 August 1930, with an all-star cast of Coward himself, as Elyot, Gertrude Lawrence as Amanda and Laurence Olivier as Victor.

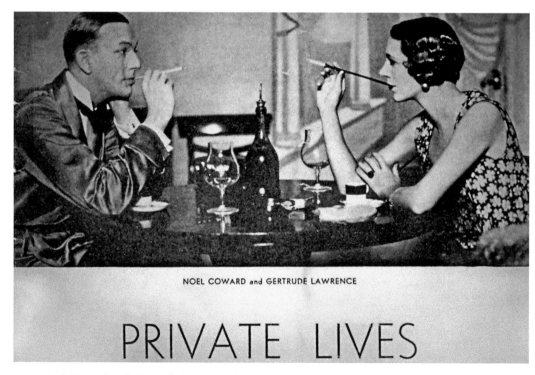

NOEL COWARD and GERTRUDE LAWRENCE

PRIVATE LIVES

Noel Coward and Gertrude Lawrence in *Private Lives*.

By mid-twentieth century the theatre in Edinburgh, as elsewhere, had experienced a change. The character of its audience had altered, and with it the plays presented. Except at rare times going to the theatre was no longer a social occasion. In the old days, stalls and circle had been resplendent with evening dress, but with the passing of each year, 'shirt fronts and sables' were of rarer occurrence. The new audience sought the theatre for its entertainment value, as they might seek the cinema. They wanted to laugh.

Edinburgh, *Third Statistical Account*, 1966

The King's Theatre has traditionally closed during the summer season. However, in 1935 Stewart Cruikshank decided to introduce a variety revue during the summer months. The *Half-Past Eight Show* had already done well in Glasgow with Jack Edge filling the theatre for the whole of the summer. Edge was brought over to the Edinburgh for the King's version of the *Half-Past Eight Show*. It was reported as 'hitting the right happy-go-lucky spirit of the late evening entertainment which was just the thing to round off an early evening's tennis or golf'. However, there was some criticism of the length of some of the items, the quality of the band and Edge, who was noted as being a first-rate comedian, but his confidential style was described as 'irritating and inaudible to people in the circle'. The show was a something of a flop and closed after six weeks.

In 1937, Cruikshank was persuaded to give the summer show another chance, with Dave Willis, a young and relatively unknown comedian, recruited as 'chief fun maker', and Charles Ross as writer and producer. The new *Half Past Eight Show* opened on 11 June

Five-Past Eight Show poster.

1937 with a trial run of four weeks. The show was billed as an 'after-dinner lightsome fare of song, dance and laughter'.

Audiences were meagre at first, but by the fourth week news of the show had spread by word of mouth and it was playing to packed houses. There was a new programme every week, and it was Dave Willis who established the shows so successfully. The *Half-Past Eight Show* became a summer tradition at the Kings with Dave Willis taking the lead for five seasons – the 1939 season ran for twenty-eight weeks. The result was that 'serious' theatre became less in evidence at the King's.

The *Half-Past Eight Show* title remained the same despite a seven o' clock start during the war years to allow people to get home safely before the blackout – the *Half-Past Eight Show* was a much-needed regular weekly tonic bringing some light relief and acting as a morale booster during the bleak days of the war. After the war, the starting time of the show was normally eight o' clock, although on occasions it was seven-thirty. The show was so well known as the *Half-Past Eight Show* that it took until 1955 for it to be rebranded the *Five-Past Eight Show*.

The shows continued into the late 1960s with Harry Gordon, the Alexander Brothers, Stanley Baxter, Andy Stewart, Jimmy Logan, Rikki Fulton and Jack Milroy as the headline acts. It was a golden age for Scottish variety, and many entertainers who would go on to become household names appeared at the King's during this time. However, the growing attractiveness of television meant that payments for stars were increasing, and this resulted in the slow but steady demise of regular variety theatre that had previously drawn huge audiences.

Dave Willis

> Willis's assets include a voice which makes itself heard without effort, and a genuine comedy flair which can make even the most common place material seem amusing. His comedy is largely broad, but not too broad; it has a pleasant facility, and is associated with a power of caricature and observation which gives it body and substance.
>
> *The Scotsman*, June 12 1937

Dave Willis (1895–1973) was the stage name of Glasgow-born David Williams. Willis was one of the biggest stars of Scottish music hall and is widely regarded as one of the greatest Scots comedians. His comedy talent first came to prominence during First World War concert parties and his career quickly blossomed after the war ended in 1918. He is variously described as a 'master of unrelated nonsense' and 'Scotland's Charlie Chaplin'. He was hailed by Chaplin himself as the funniest man on the British stage. He was a master of the comic song and his best-known ditty, 'My Wee Gas Mask', was a wartime favourite, sending audiences wild with patriotic fervour during the darkest days of the Second World War.

Dave Willis.

Francie and Josie

Rikki Fulton joined the *Five-Past Eight Show* company in 1955 and in 1960, along with Jack Milroy, first brought the loveable layabouts Francie and Josie to life at the King's. Although the characters were Glasgow-wide boys, the Edinburgh audiences loved them – as did the whole country when they moved to TV. Rikki's later *Scotch and Wry* television programme introduced the doom-laden I. M. Jolly and the inept Supercop.

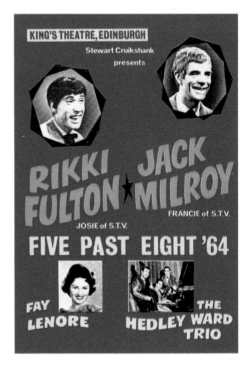

Five-Past Eight Show poster from 1964 featuring Jack Milroy and Rikki Fulton as Francie and Josie.

Fay Lenore appeared frequently with Francie and Josie at the King's. A talented singer and dancer, she was a regular performer from age fifteen and started playing Principal Boy in pantomimes from the age of seventeen.

Fifties Alterations

In 1951, the King's was closed for ten months for the first significant alterations since it opened in 1906. The top gallery – the gods – was removed due to a structural problem and the upper circle was extended with 300 additional seats added, although the overall seating capacity was reduced from the original 1,800 to 1,500 and has subsequently lowered to 1,300. The owners noted that they regretted 'the inconvenience that will be caused by the elimination of the many cheaper priced seats'. The theatre was partially opened for the 1951 Edinburgh Festival and fully opened on 14 December 1951, with the pantomime *Puss in Boots*.

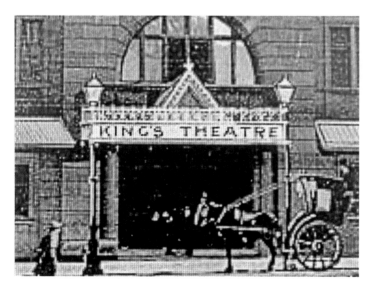

The original canopy at the King's.

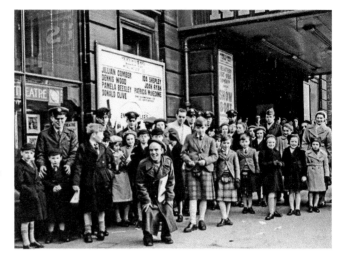

A happy group outside the King's Theatre wait under the new canopy for a production of *Show Boat* in the 1950s. The men in uniform are military personnel from the American airbase at Kirknewton. (Photograph courtesy of Seonaidh Guthrie)

The original ornate glass-entrance canopy with its stained-glass panels, which was supported by metal pillars at the edge of the pavement, was replaced with a more modern cantilevered design at the time.

The Acts

Over the decades, the King's has played host to some of the greatest national and international performers and companies, and the biggest stars of opera, dance, variety, screen and stage.

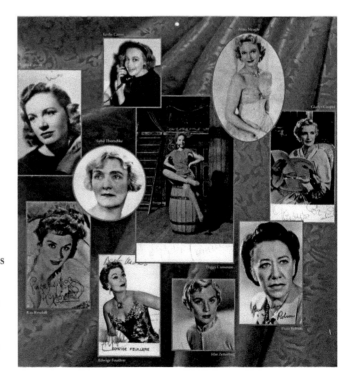

A selection of the female stars that have appeared at the King's: Leslie Caron, Anna Neagle, Gladys Cooper, Peggy Cummins, Sybil Thorndike, Phyllis Calvert, Kay Kendall, Flora Robson, Mai Zetterling and Edwige Feuillere.

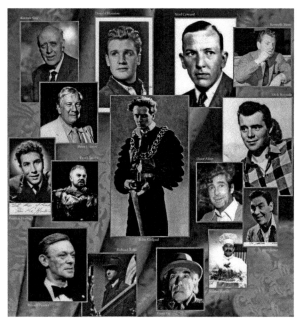

A selection of the male stars that have appeared at the King's: Alastair Sim, Donald Houston, Noel Coward, Kenneth More, Dirk Bogarde, Dave Allan, John Gielguid, Derek Jacobi, Peter Ustinov, Frankie Howerd, Russell Hunter, Richard Todd, Frank Finlay, Stanley Baxter and John Slater.

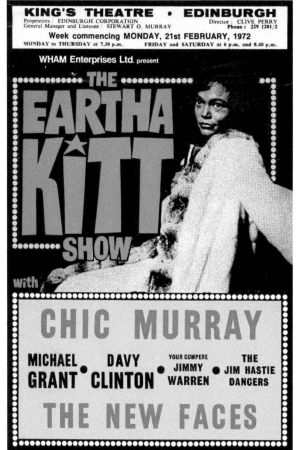

Playbill for Eartha Kitt's appearance at the King's in the week commencing 21 February 1972. A mixed line-up, with the Scottish surreal comedian Chic Murray second on the bill.

Dame Sybil Thorndike

Sybil Thorndike made her first appearance in Edinburgh at the King's on 30 June 1923 in a production of *The Scandal*. It was described as a 'notable performance and the distinguished tragic actress had no cause to complain of her reception'.

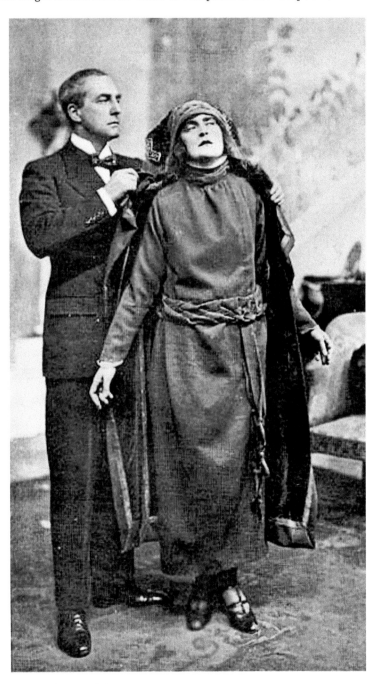

Sybil Thorndike in *The Scandal*.

Sean Connery

In 1944, a young local lad by the name of Thomas Sean Connery, who had been born in a 'single end' in Fountainbridge, earned his first wage as a barrow worker at the St Cuthbert's Co-operative Association's dairy in Corstorphine. Sir Sean, or 'Big Tam' as he was then known, left St Cuthbert's in 1948 to do his national service, but returned the following year and worked as a milk-horse man. He remained with the company until January 1950 and if the local hyperbole is to be believed, then Sir Sean once delivered milk to almost every household in Edinburgh.

Sir Sean also worked as a French polisher, a coalman, a male model, a lifeguard at Portobello Pool and a bouncer at Fountainbridge's Palais de Danse. It is perhaps less well known that he worked backstage at the King's Theatre in 1951 and made an early stage appearance at the King's in the play *The Seashell* before going on to find fame and fortune as the first James Bond.

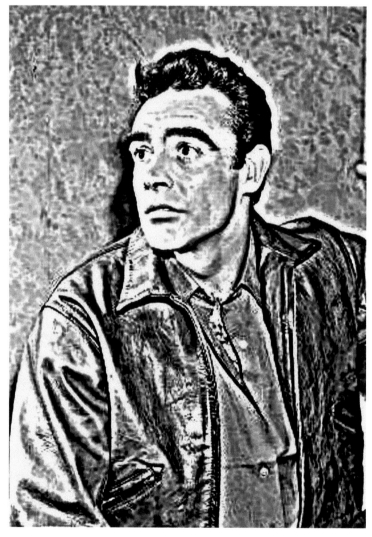

Sean Connery at the King's.

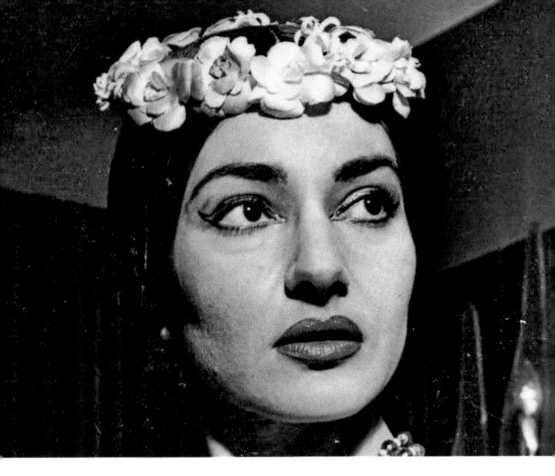

Above: Maria Callas.

Right: Programme cover for the performances by Maria Callas at the King's in 1957.

UNDER THE PATRONAGE OF HER MAJESTY THE QUEEN
AND HER MAJESTY QUEEN ELIZABETH THE QUEEN MOTHER

Edinburgh International Festival

*In association with the Scottish Committee of
the Arts Council of Great Britain, the British Council
and the Corporation of the City of Edinburgh*

LA PICCOLA SCALA

presents

La Sonnambula

By VINCENZO BELLINI

KING'S THEATRE · 1957

Maria Callas

The King's Theatre specialised in opera from the start of the Edinburgh Festival in 1947. Maria Callas sang with the La Scala Company at the King's in the role of Amina for four performances of Bellini's *La Sonnambula* during the Edinburgh Festival in August 1957 – 'with the triumphant assurance of a great prima donna'. This was her only appearance in the UK outside of London and it ended in controversy. Callas had been contracted for the four performances, but because of the opera's great success, La Scala announced a fifth performance. Callas was committed to another engagement in Venice and, considering that she had fulfilled her contractual obligations, refused to appear. This was the start of a strained relationship between Callas and La Scala.

All the World's a Stage

The King's was the subject of a major restoration in 2012, which was the first significant work on the building since a refurbishment scheme in 1985. The work included new seating, enhanced access, general repairs and decoration.

During the restoration, the ceiling of the main auditorium was repaired and replastered. The existing *trompe l'oeil* decoration of the dome by William McLaren dated from 1985 and the work presented the Festival City Theatres Trust with the opportunity to consider a new decorative scheme for the ceiling.

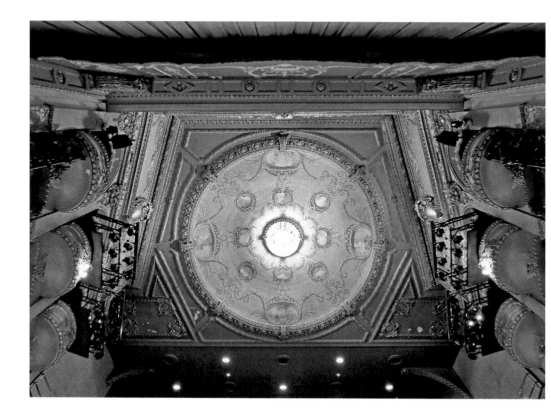

The 1985 *trompe l'oeil* decoration of the dome.

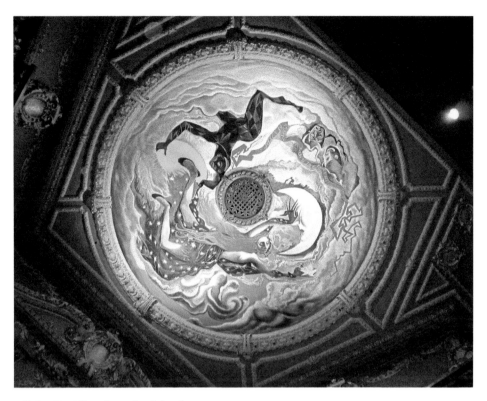

All the World's a Stage by John Byrne.

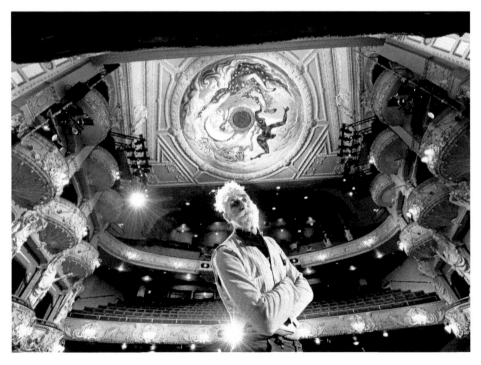

John Byrne at the King's.

In 2013, the trust commissioned celebrated Scottish artist and writer John Byrne to create a new artwork for the ceiling. Byrne's vivid design is rich in theatrical symbolism and references – including this line from Shakespeare's *As You Like It*: 'All the world's a stage, and all the men and women merely players.'

The design was projected onto the dome and was traced and painted by a team of painters in June/July 2013. It greatly enhances the theatre and was unveiled on Tuesday 6 August 2013, just in time for the Edinburgh International Festival performance of *Metamorphoses* at the refurbished King's.

The Gang Show

The King's supports Edinburgh's long tradition of amateur operatic and musical societies – Southern Light, the Edinburgh Gilbert and Sullivan Society and the Bohemians Lyric Opera Company.

It also hosts the annual Edinburgh *Gang Show* performance. The Gang Shows – originally restricted to Boy Scouts but now extended to Girl Guides – have been a tradition at the King's since 1960 and continue to fill the theatre. The shows, featuring song, dance

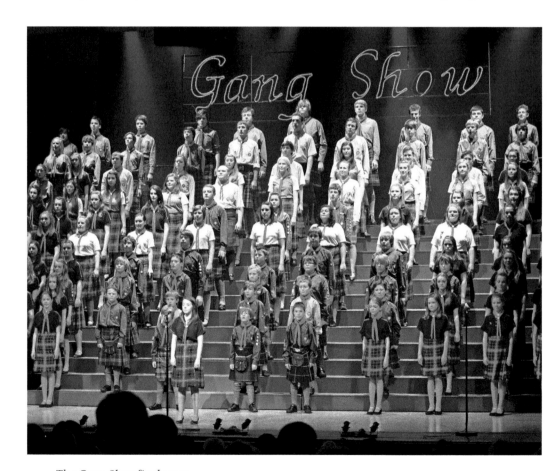

The *Gang Show* finale 2011.

and comedy routines, were the idea of Ralph Reader and started in London in 1932. The finale of every *Gang Show* usually sees the performers and audience happily 'Riding Along On the Crest of a Wave.'

Pantomime

> The National Theatre of Scotland is Pantomime.
>
> Sir Lewis Casson, actor/director,
> husband of Dame Sybil Thorndike, speaking in the 1920s.

A visit to a pantomime is a long-standing Christmas tradition and as much part of the festive season as turkey, mince pies and crackers.

One dictionary definition of pantomime is 'a theatrical entertainment, mainly for children, which involves stock character types, music, dancers, topical jokes, and slapstick comedy and is loosely based on a fairy tale or nursery story, usually produced around Christmas'. This seems like a perfect definition, only missing out the obligatory audience participation – 'It's behind you!' and 'Oh no, you don't!', and the appeal that panto has for all ages and not just children.

The word 'pantomime' was first used in an advert in the *London Daily Courant* of 2 March 1717, when a production at the Drury Lane Theatre was featured as being 'after the manner of the Ancient Pantomimes'. John Weaver, the Drury Lane's dance master, intended the

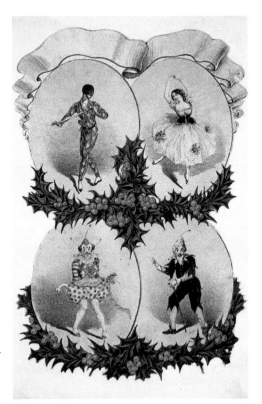

Harlequin, Columbine, Clown and Pantaloon – traditional characters from the early harlequinades that were an important part of early pantomimes.

Posters for the Howard & Wyndham pantos at the King's.

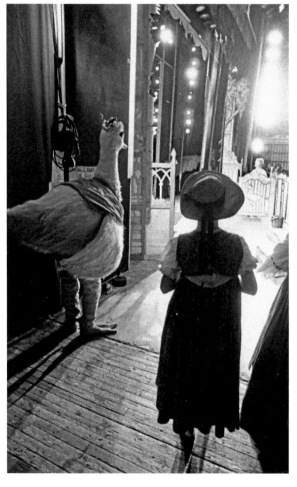

Mother Goose waits in the wings to make her entrance. Pantomime has always taken great amusement in actors dressed as animals, known as 'skin parts'.

term to refer to the *pantomimi* of Ancient Rome whose performances incorporated clowns, dance and music.

Pantomime evolved through the theatrical farces of the sixteenth-century Commedia Dell' Arte in Italy, and by the eighteenth century any form of theatre that included a standard story, humour and song was generally known as pantomime. The Victorians were the first to include the now standard panto themes of good overcoming evil in the guise of traditional fairy tales, and to associate pantomime with Christmas and children. In the later nineteenth century, the glitzier features of music hall were introduced. Present-day pantomime is a charming potpourri of all of these traditions, a mix of comedy and sentiment, and remains enduringly popular with Scottish audiences, which have an exceptional fondness for panto.

Howard & Wyndham specialised in extravagant pantomime productions starring élite music-hall stars. The Wyndham family presented their first pantomime in Edinburgh as early as 1851. The opening performance at the King's on the 8 December 1906 was the pantomime *Cinderella* and the annual pantomime tradition at the theatre has continued ever since.

Stanley Baxter in full panto mode.

Andy Gray, Grant Stott and Allan Stewart.

The King's made a break from the traditional panto themes in the early sixties with the tartan-inspired and much-loved Jamie pantomimes – *A Wish for Jamie*, *A Love for Jamie* and *The World of Jamie*. The *Edinburgh Evening News,* on 15 December 1962, under the headline 'SCOTTISH PANTO IS A BOMBSHELL', described the opening night of *A Wish for Jamie*:

> With the first act finale having all the appearance of a miniature military tattoo, *A Wish for Jamie* burst on the capital last night like a tartan bombshell, sending bagpipes, heather and haggis showering in all directions. The audience whistled, they clapped, they sang and they cheered. A puff of smoke brought Aggie Goose, a Scottish fairy played by Marilyn Gray, sweeping across the stage, astride a Scottish version of a broomstick, a set of bagpipes in McLeod tartan. There is much humour and a good deal to help one forget the cares of the day in this show. In fact it has all the ingredients one expects of festive season entertainment.

In later years Stanley Baxter, the king of the panto dames, Jack Milroy, Rikki Fulton, Walter Carr, Johnny Beattie, and Jimmy Logan, carried on the tradition before an audience of happy panto-goers.

In more recent years, the stalwarts of the King's panto and the inheritors of a long tradition of Scottish comedy have been Allan Stewart, Andy Gray and Grant Stott. Resident dame Allan Stewart made his first appearance in the King's panto as far back as 1989 and debuted as dame in 1997 in *Jack and the Beanstalk*. The irrepressible trio of Stewart, Gray and Stott first got together in 1998 for *Aladdin*. By the time of *Snow White* in 2002, Stewart and Gray were established as a double act and Andy first noted that he was 'no very well'. In 2003, Grant Stott made his debut as the villain Flesh Creep in *Jack and the Beanstalk*, and he has been an immensely successful baddy ever since.

Relaxed Performances

The King's Theatre hosts an annual 'relaxed performance' of the pantomime, exclusively for over 600 children from all eleven of the city's special schools. There is a relaxed attitude to noise and movement in the auditorium and some small changes made to the light, sound and special effects of the show. The Festival City Theatres Trust hosted Scotland's first relaxed performance with a special show of *The Snowman* at the Festival Theatre in December 2012.

Two kids enjoying a relaxed performance of *Snow White*.

Later Years

In 1969, the theatre was sold to the local authority to ensure its future. At this time the King's was the predominant theatre in Edinburgh the Empire was being used for bingo and the Playhouse was a cinema. In 1985, the council financed a major refurbishment of the King's interior and in 2012 the exterior was extensively restored and a new box office added.

In 1997, the King's and Festival Theatres merged under the management of the Festival City Theatres Trust.

Backstage and Front of House at the Festival and King's Theatres

The activity in a theatre is not confined solely to the stage. Theatres and theatrical productions depend on a wide range of backstage and front of house staff and expertise to allow the show to go on – stage managers, lighting engineers, stage crew, dressers, scenery designers, box office staff, bar and office staff; ushers and usherettes. All of these functions require skilful co-ordination to ensure the smooth running of performances.

Meeting and greeting the audience at the door of the theatre was once considered an important part of the experience of theatre-going. This fine gent in full Howard & Wyndham livery harks back to the time when you would be greeted at the door of the King's theatre by a commissionaire.

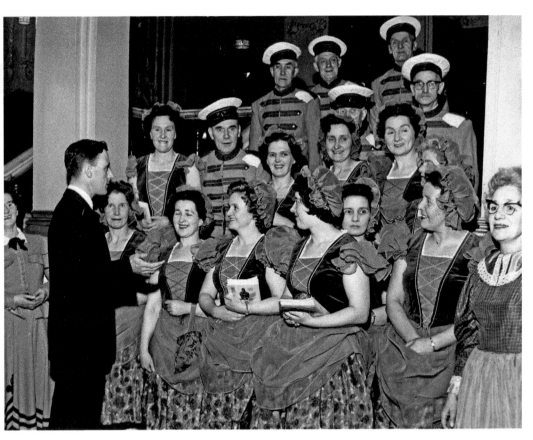

A group of ushers and usherettes in costume are briefed before a performance in the 1950s.

Rachel and Steve at the box office at the Festival Theatre in 2016.

Above: A busy dressing room at the King's. Actors apply their own make-up and the mirrors in the dressing rooms have numerous light bulbs around them to simulate the lighting conditions on the stage.

Left: The control panel backstage at the Festival Theatre from which lights, scenery changes and performers are cued.

Rigger setting up the scenery at the top of the fly tower at the Festival Theatre. Flymen then use a system of pulleys and ropes to fly in the scenery during the performance. In the early days of the theatre, sailors were often employed as riggers and flymen because of their shipboard experience handling ropes. They would communicate instructions for scenery changes by a system of whistles. This resulted in the theatrical superstition that whistling on stage was bad luck, as scenery might be dropped at the wrong time.

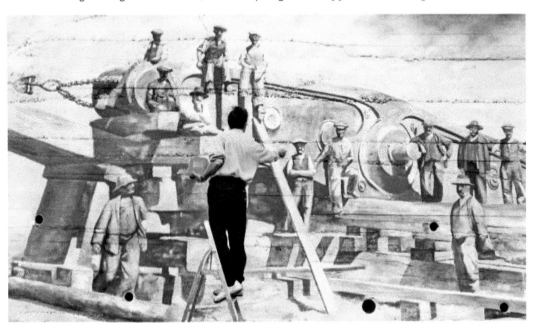

The skills of the scene painter are an essential part of the magic of theatre.

The stage door in the latter days of the Empire (top) and the present Festival Theatre stage door.

The stage door signs at the King's.

Also Available from Amberley Publishing

This fascinating selection of photographs explores Edinburgh at its monumental best.

Paperback
100 illustrations
96 pages
978-1-4456-5007-4

Available from all good bookshops or to order direct
please call **01453-847-800**
www.amberley-books.com